Coloured things
Stages 1 & 2

A Unit for teachers

D0178591

Published for the Schools Council by
Macdonald Educational, London and New York .

© Schools Council Publications 1973

First impression 1973
Second impression (with amendments) 1975

ISBN 0 356 04348 7

Published by
Macdonald Educational
49–50 Poland Street
London W1

850 Seventh Avenue
New York 10019

The chief author of this book is:

Sheila Parker

The other members of the Science 5/13 team are:

Len Ennever Project Director

Albert James Deputy Project Director

Wynne Harlen Evaluator

Don Radford
Roy Richards
Mary Horn

Made and printed by Waterlow (Dunstable) Limited

General preface

'Science 5/13' is a Project sponsored jointly by the Schools Council, the Nuffield Foundation and the Scottish Education Department, and based at the University of Bristol School of Education. It aims at helping teachers to help children between the ages of five and thirteen years to learn science through first-hand experience using a variety of methods.

The Project produces books that comprise Units dealing with subject areas in which children are likely to conduct investigations. Some of these Units are supported by books of background information. The Units are linked by objectives that the Project team hopes children will attain through their work. The aims of the Project are explained in a general guide for teachers called *With objectives in mind* which contains the Project's guide to Objectives for children learning science, reprinted at the back of each Unit.

Acknowledgements

The Project is deeply grateful to its many friends: to the local education authorities who have helped us work in their areas, to those of their staff who, acting as area representatives, have borne the heavy brunt of administering our trials, and to the teachers, heads and wardens who have been generous without stint in working with their children on our materials. The books we have written drew substance from the work they did for us, and it was through their critical appraisal that our materials reached their present form. For guidance, we had our sponsors, our Consultative Committee and, for support, in all our working, the University of Bristol. To all of them we acknowledge our many debts: their help has been invaluable.

Metrication

This has given us a great deal to think about. We have been given much good advice by well-informed friends, and we have consulted many reports by learned bodies. Following the advice and the reports whenever possible we have expressed quantities in metric units with Imperial units afterwards in square brackets if it seemed useful to state them so.

There are, however, some cases to which the recommendations are difficult to apply. For instance we have difficulty with units such as miles per hour (which has statutory force in this country) and with Imperial units that are still in current use for common commodities and, as far as we know, liable to remain so for some time. In these cases we have tried to use our common sense and, in order to make statements that are both accurate and helpful to teachers, we have quoted Imperial measures followed by the appropriate metric equivalents in square brackets if it seemed sensible to give them.

Where we have quoted statements made by children, or given illustrations that are children's work, we have left unaltered the units in which the children worked—in any case some of these units were arbitrary.

Contents

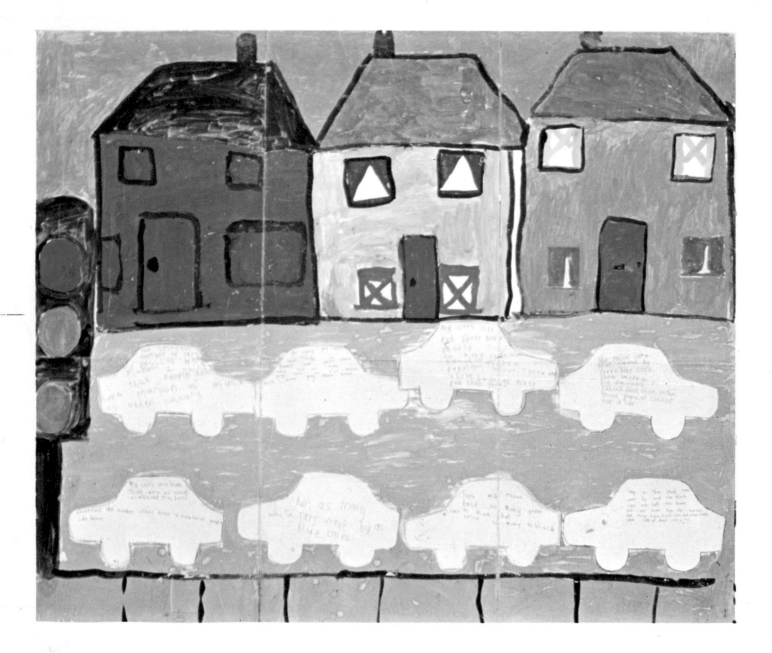

Introduction

The Unit is about *coloured things:* it is not solely concerned with colour. This is an important distinction for it is written with particular children in mind. These children are at early stages in their development of scientific understanding and their interests and enthusiasms cover a wide range. They are as likely to end up studying Eskimos, via rainbows and Northern Lights, as they are to investigate adhesives, starting with an interest in coloured papers. Such an eclectic approach is reflected in the Unit. Some of its suggestions for children's activities relate directly to colour itself whilst others use an interest in coloured things as a springboard to other areas of investigation, since this is the way young children operate.

But the Unit is not just a haphazard collection of ideas. It is designed to offer teachers help on two fronts:

Direct help with classroom activities.

Longer-term guidance in thinking about the nature of children's scientific development.

Getting help from the Unit

Ideas for children's activities
A preliminary scan of Chapters 2, 3, 4 and 5 will give you an over-all impression of possible work. Each chapter has an environmental theme rich in starting points and contains suggestions for related activities. But there is no rigid demarcation between the contents of each 'activity' chapter. Consequently, once work is underway you will find the subject index helpful for locating other activities in the Unit which become relevant to the interests that develop in your particular class.

Thinking about the nature of children's work
When you look through the activity chapters of the Unit you will automatically assess their suggestions in terms of your own class '. . . they'd like that', '. . . that's too difficult', '. . . I wonder if that would work'. These chapters are directly concerned with the what and how of classroom events, but underlying all that's written in the Unit is a concern also for the why of children's activities. Why should we encourage children to do particular things? Why should we provide them with the kind of experiences suggested in the Unit? Why, in particular, should we help them to undertake explorations and investigations that are time-consuming and frequently unproductive if assessed in terms of the factual information they yield?

Thinking along these lines inevitably leads to a consideration of what we hope children will achieve from their work or, put into other words, a consideration of the objectives we hold for them. Now different teachers will have different objectives for their children and a detailed discussion of all objectives relevant to a study of coloured things is beyond the scope of the Unit. Nevertheless, Chapter 1 discusses certain objectives involved when children work with coloured things, and it outlines ways in which thinking about objectives can have helpful practical applications. We recommend that you read this chapter before starting work and apply its general points to your own particular situation.

Further information about objectives is given in the preface and at the back of the Unit in 'Objectives for children learning science, Guidelines to keep in mind'. The guidelines are reprinted from the Project book *With objectives in mind* and we suggest that you read this book to understand the general philosophy of the Project and so put *Coloured things* in a wider context.

1 Making a start

There is no problem about finding suitable materials for starting work with this Unit. Every school contains and is surrounded by an abundance of coloured things, and potential starting points are legion. But potentiality does not necessarily become actuality, so let us consider some ideas that teachers have found helpful.

Finding a starting point

If the kind of work described in this Unit is a new venture you will find it helpful to start by developing 'science' from things the children normally do.

In the right hand column are some popular examples accompanied by reference to the Unit's chief source of ideas for development.

Experienced teachers frequently favour work that starts from some chance event; a sudden rainbow, an oil patch in the playground, a Spirograph brought to school. All these have triggered off exciting work. But someone once said 'chance favours the prepared mind' and this is particularly true for teachers engaged in child-centred inquiry.

Here is an experienced teacher talking about her preparation:

'I know what's available around and about the school, but I am constantly amazed at how little I really notice. When I'm planning a new topic I go out and look very hard. I try to see things as the children would. I'm after things that will capture their interest and start them talking, or things that may get them going as the result of the odd remark from me. All the time I'm summing up the possibilities for things that they can *do* and how

Starting point	Unit page reference
Artwork	
Painting	46
Tie dyeing	54
Number work	
Traffic census	35
Graphs and sets of hair and eye colour	8
Collections	
Colour corners	13
Wild flowers	26
Work with animals	
Pets	22
Bird-watching	19
Expeditions	
The countryside	19
Town parks	19
City streets	35

they might start doing—leading questions and things like that. Having done all this I then "play it by ear". I might deliberately set them off on what appears to them to be self-chosen work, or I might hang back and wait for something to crop up that will start us all working. If it comes I'm ready for it.'

Notice in the quotation the emphasis on taking stock of the environment and the thinking out of leading questions. The environmental themes of the Unit are planned to help you do this in your own situation; each chapter contains many questions which we hope will suggest ways of stimulating and sustaining profitable explorations.

Sorting out Objectives

Children at what we have called Stages 1 and 2* will benefit from experience of colour in the widest possible sense. Theirs is a *doing* stage in which any work leading to an understanding of colour itself is but part and parcel of activities which help their general understanding of science and their general personal development. These children, approaching materials with the full use of all their senses, naturally delight in the colourful things around them, and work on colour is likely to occur and recur intermittently in the classroom. Sometimes it may be the dominant interest: sometimes it may be incidental to other things. Whatever the degree of prominence it is worth thinking about what the children will gain from their work, that is, what objectives they are likely to achieve.

We will pinpoint some that can be kept in mind when children work with coloured things.

Stage 1 Objectives
The emphasis at this stage is on giving children rich general experience of colour that will benefit later work of a more sustained and organised nature. We can help children to explore and talk about coloured materials in order that they might work towards such things as:

Appreciation of the variety of living things and materials in the environment.

Awareness of change of living things and non-living materials.

* For explanation and details see 'Objectives for children learning science—Guide lines to keep in mind' at the back of the Unit, and With objectives in mind.

Ability to predict the effect of certain changes through observation of similar changes.

Awareness of sources of heat, light and electricity.

Awareness that there are various ways of expressing results and observations.

Willingness to wait and to keep records in order to observe change in things.

And we can help them communicate their findings in ways that encourage among other things their *ability to tabulate information and record impressions by making models, paintings or drawings.*

Of course these are not the only relevant objectives. Why not consult the statement at the back to select and if necessary, modify, those you think most suitable for your children?

Stage 2 Objectives
Stage 2 grows from Stage 1 experience: it is a development of earlier work. However the previous objectives still apply, for children still need to gather general experience of coloured things and their properties. But at Stage 2 they can do this using increased manipulative skill and more sustained interest and so their observations can involve finer detail and events of longer duration. At the same time they can make more use of what they notice.

Perhaps isolated observations can be related in some way. Is there, for example, any connection between eye colour and hair colour? Here's a problem requiring further investigation involving them in organising and interpreting observations, and in critical discussion. (Will they get the same result if they investigate another class?... the whole school?)

Perhaps also their observations prompt questions to be answered by experiment. This may occur at a very simple level (Do red lollies melt faster than yellow ones?), but they have value not so much for the answers they give as for the work involved in obtaining the answers. (How can they make a 'fair' test for the lollies?) Such activities will likely open up new lines of investigations. (What would they find if they used other colours? Can

they make a blue lolly? What would happen if they used plain ice in different coloured wrappers? ...? ...?)

The progression from observation to true investigation is an aspect of work that some teachers find difficulty in handling. Yet it is a crucial one in the development of scientific understanding, and having clear objectives can make things easier. We need to help children explore possible relationships between observations and to investigate problems in an increasingly critical manner. For such work we might keep the following Stage 2 objectives in mind:

Ability to frame questions likely to be answered through investigations.

Appreciation of the need to control variables and use controls in investigations.

Recognition of the role of chance in making measurements and experiments.

Preference for putting ideas to test before accepting or rejecting them.

Skill in devising and constructing simple apparatus.

Willingness to examine critically the results of their own and others' work.

There are of course other objectives equally worth while. Have a look at the statement at the back of the Unit. Which do you consider relevant to your children?

Working with Objectives

Objectives are not statements that have to be slavishly worked towards. If you think of them as aids to interpreting classroom events in terms of what the children might get from their work, then they can have a very useful function.

A cursory glance at Flow chart 1 shows that it represents good infant practice. The children started from a point of immediate interest; they were actively exploring materials and had a variety of experiences.

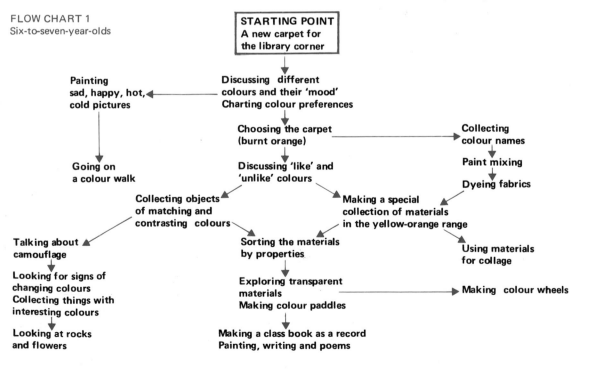

FLOW CHART 1
Six-to-seven-year-olds

STARTING POINT
A new carpet for
the library corner

Discussing different colours and their 'mood'
Charting colour preferences

Painting sad, happy, hot, cold pictures

Choosing the carpet (burnt orange)

Collecting colour names

Going on a colour walk

Discussing 'like' and 'unlike' colours

Paint mixing

Dyeing fabrics

Collecting objects of matching and contrasting colours

Making a special collection of materials in the yellow-orange range

Talking about camouflage

Sorting the materials by properties

Using materials for collage

Looking for signs of changing colours
Collecting things with interesting colours

Exploring transparent materials
Making colour paddles

Making colour wheels

Looking at rocks and flowers

Making a class book as a record
Painting, writing and poems

If you relate what they did to the Objectives at the back of this book you will find a large number of Stage 1 Objectives implicit in their work—far too many to list here. You might also notice that some Objectives are not necessarily covered by the children's activities, although they could be applied to working with coloured things. For example:

Ability to predict the effect of certain changes through observation of similar changes.

The example illustrates one useful function of objectives:

Thinking about Objectives can pinpoint opportunities for learning which we might otherwise neglect.

For instance, if we are aware that experience of predicting change is of value in the development of children's scientific understanding, we might profitably look for opportunities to provide this kind of experience.

Perhaps when they are mixing paint or when they are on a walk looking at colour there might be a chance to develop situations where they are *consciously* concerned with predictions. Such situations may not arise; here's reason to keep the objective in mind for future work.

Flow chart 2 shows what happened when a class of eight- to nine-year-olds became interested in coloured things. In terms of objectives it is very like that of Flow chart 1, though much more extensive as a result of the sustained interest of older children.

The basic similarity of the work in the two examples illustrates an important point. When children come into contact with new materials or look at familiar things in a new light, they need wide general experience *whatever their age.* Some may linger long at this stage; others are soon ready to progress further.

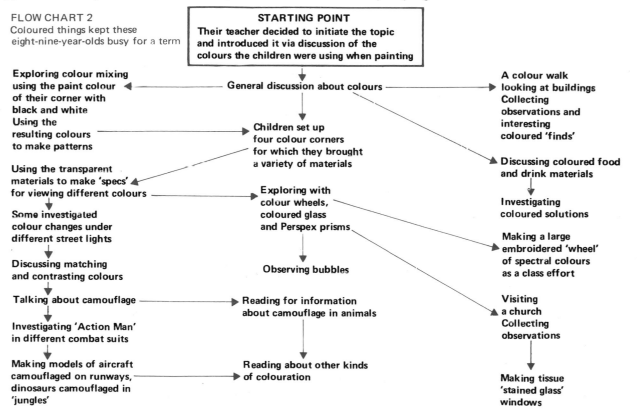

FLOW CHART 2
Coloured things kept these
eight-nine-year-olds busy for a term

STARTING POINT
Their teacher decided to initiate the topic
and introduced it via discussion of the
colours the children were using when painting

General discussion about colours

Exploring colour mixing using the paint colour of their corner with black and white
Using the resulting colours to make patterns

Using the transparent materials to make 'specs' for viewing different colours

Some investigated colour changes under different street lights

Discussing matching and contrasting colours

Talking about camouflage

Investigating 'Action Man' in different combat suits

Making models of aircraft camouflaged on runways, dinosaurs camouflaged in 'jungles'

Children set up four colour corners for which they brought a variety of materials

Exploring with colour wheels, coloured glass and Perspex prisms

Observing bubbles

Reading for information about camouflage in animals

Reading about other kinds of colouration

A colour walk looking at buildings
Collecting observations and interesting coloured 'finds'

Discussing coloured food and drink materials

Investigating coloured solutions

Making a large embroidered 'wheel' of spectral colours as a class effort

Visiting a church
Collecting observations

Making tissue 'stained glass' windows

And here's a second helpful function of Objectives:

Thinking about Objectives can help us to cater for the progressive use of the same material.

For example, in the discussion about camouflage (Flow chart 2) the boys contributed a lot of information about its military use and 'Action Man' soon arrived at school. Here was a source of good teaching material—how then to exploit it? Clearly there's much scope for general exploration of camouflage through making models with different backgrounds and discussing their effectiveness, also there is the possibility that the work will branch out to include other materials, such as aircraft or dinosaurs, used in a similar way. But what about *extending* the work? Perhaps some children could go further.

If you have particular Stage 2 Objectives in mind, say those concerning experiments and investigations, then these may trigger off ideas for development. Could the interest in 'Action Man' be turned into an experimental situation? For example:

How much more effectively is he camouflaged in one situation compared with another?

Could the children design a 'fair test'?

Could they make measurements to support their investigations?

In this manner we can use Objectives to help children who are ready to extend their activities beyond Stage 1 exploration.

Finally let us consider the work of another class shown in Flow chart 3. These were ten- to eleven-year-old children and we would expect to find more Stage 2 work in evidence. Now the development from Stage 1 and Stage 2 is not a sudden happening and it cannot really be tied to age because it depends on earlier experience. But a ten-year-old will have more experience than a six-year-old and so it is likely that his work will show corresponding development. It is worth remembering also that there may be in a class of ten- to eleven-year-olds, children who are beginning to be able to make abstractions about their experience, to generalise and see patterns in ways that other children cannot yet grasp. These are children reaching what we have called Stage 3 and if you examine the Stage 3 Objectives at the back of the Unit, applying them to the materials your children work with, you may get ideas for meeting their needs.

Look now at Flow chart 3 on the opposite page; it illustrates one further point about Objectives:

Objectives can be used as a check that children are getting a 'balanced diet' of experience.

The flow chart records what the children did. If we interpret it in terms of the Objectives involved we can better appreciate the kind of experience they had and get ideas for future work. For example:

The fish group were working almost exclusively from books and so their work centred on Objectives relating to acquiring knowledge and communicating. Perhaps they could be encouraged to branch out more? They might be guided into looking at live fish (can fish see colour?) or devising experiments relating to the information they have been recording. Or they might stay with their books, but their teacher with a range of Objectives in mind could guide their future work along other lines.

Of course teachers are constantly carrying out checks such as this to make sure that the work of individual children is not one-sided. But some find this difficult to do in relation to science. It is here that the statement of Objectives can be of help, and the Project team hopes that teachers will make use of it in whatever ways they find helpful; at the planning stage, when work is progressing, or when it is complete.

FLOW CHART 3
Ten-eleven-year-olds with considerable experience of investigational work
and who were used to working independently at self-chosen tasks

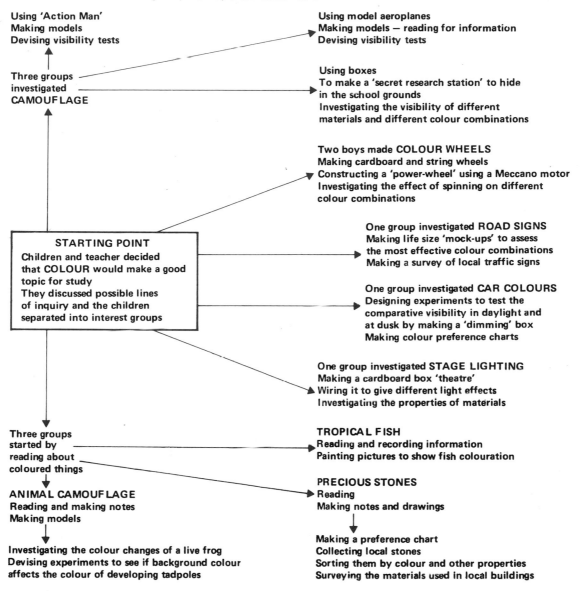

Using 'Action Man'
Making models
Devising visibility tests

Using model aeroplanes
Making models — reading for information
Devising visibility tests

Three groups
investigated
CAMOUFLAGE

Using boxes
To make a 'secret research station' to hide
in the school grounds
Investigating the visibility of different
materials and different colour combinations

Two boys made COLOUR WHEELS
Making cardboard and string wheels
Constructing a 'power-wheel' using a Meccano motor
Investigating the effect of spinning on different
colour combinations

STARTING POINT
Children and teacher decided
that COLOUR would make a good
topic for study
They discussed possible lines
of inquiry and the children
separated into interest groups

One group investigated ROAD SIGNS
Making life size 'mock-ups' to assess
the most effective colour combinations
Making a survey of local traffic signs

One group investigated CAR COLOURS
Designing experiments to test the
comparative visibility in daylight and
at dusk by making a 'dimming' box
Making colour preference charts

One group investigated STAGE LIGHTING
Making a cardboard box 'theatre'
Wiring it to give different light effects
Investigating the properties of materials

Three groups
started by
reading about
coloured things

TROPICAL FISH
Reading and recording information
Painting pictures to show fish colouration

ANIMAL CAMOUFLAGE
Reading and making notes
Making models

PRECIOUS STONES
Reading
Making notes and drawings

Making a preference chart
Collecting local stones
Sorting them by colour and other properties
Surveying the materials used in local buildings

Investigating the colour changes of a live frog
Devising experiments to see if background colour
affects the colour of developing tadpoles

2 Classroom colours

Looking at themselves

Any class is a collection of varied individuals with different physical characteristics. It is a good source for investigations which encourage children to think more about the differences that exist between them and to discuss these objectively as variations of a common plan. Racial 'differences' including different skin colours can be investigated by the children in matter of fact ways and subsequent discussions help them see these 'differences' in a wider perspective.

Looking at eyes
What is the commonest eye colour within the class? The results are easily graphed since few classes will have the following problem. 'Malcolm spoilt our record. He's got one blue eye and one green eye!' How do the results for the whole school compare with results from their class?

Let the children examine their own eyes using a small mirror.

Is the eye really blue . . . brown . . . grey . . .?

Is the 'white' really white?

Can they estimate the size of the coloured part? Some might make a comparative estimate—as big as a Others might try to estimate the coloured part as a fraction of the whole.

What eye colours are there in the children's families? Here without understanding fully they can gain experience of the transference of hereditary characteristics. Broadly speaking, eye colour is determined by two factors. One,

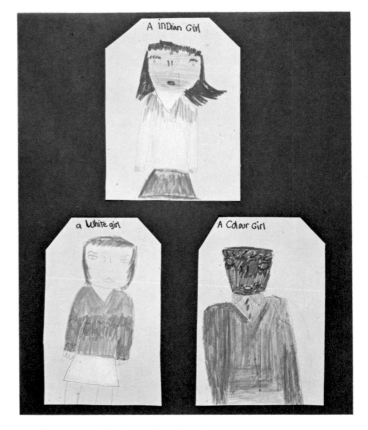

An eight-year-old's view of multiracial faces

responsible for brownness, is dominant to the other blue factor which is said to be recessive. The mechanics of this relationship are beyond the children's understanding at this stage. But if they collect sufficient information about families and attempt to organise their findings, they might make some generalisations. Perhaps just discovering that:

Two blue-eyed parents always have blue-eyed children.

But:

Two brown-eyed parents do not necessarily have only brown-eyed children.

(*Note*. Work of this kind could cause distress to brown-eyed children who are unaware that their blue-eyed parents are adoptive ones.)

Encourage investigations of possible connections between eye colour and other characteristics. Is there for example, any connection between eye colour and:

hair colour
skin colour
the shape of the ears
the kind of fingerprint?

The answers might well be No. This is not important. What matters is that the children are involved in an inquiry whose 'answer' is unknown. They must collect information and interpret their own findings and in doing so will gain valuable experience.

Once children get involved in work of this kind they may get ideas for further lines of inquiry. Do, for example, brown-eyed children have better vision than those with blue eyes? It's an interesting problem and a good example of the need to recognise a 'fair' procedure of testing.

Is anyone in the class colour blind? Let the children devise a method of testing and if colour blindness comes to light, as is possible, the individuals concerned are more likely to accept their condition as an interesting variation rather than a deficiency.

One group of children based their testing on colour matching. They collected paper squares of varied colours, cut each in half, jumbled them up and then invited others to rematch the squares. Initially they used any paper they could find, but soon learnt that texture is as important as colour in the matching process. Recognising then the inadequacies of their test they devised ways of making it a fair one. Their results suggested that two boys were colour blind and this was checked using a standard test for colour blindness borrowed from the school medical service.

Incidentally some scientists have claimed that people can 'feel' colour with their fingers. Is this true? Children will get a lot of enjoyment in devising a fair test.

When investigating eyes, don't forget sunglasses. They come in a variety of colours. Try comparing the colours of objects when looked at through different coloured

In my class there are white children, West Indians and Indians. I found that do white children have these hair colours, blond, ginger, brown and black. West Indians have brown or black hair. Indians have black hair. White children have lots of different eyes. West Indians and Indians have brown eyes.

'specs' (see page 14). Polaroid glasses are interesting too. They can reveal colours in unexpected places. Car windscreens are good examples; let the children collect others. They can do this without understanding *why* it happens. Sufficient at this stage for them to discover that polaroid glasses have different properties from 'ordinary' glasses and to note what those differences are.

Looking at skins

Is white skin really white? Let the children examine their skin closely. They will find quite a lot of individual variation; some will have darkish skin with lots of melanin pigment, some have very fair skin.

Can they classify themselves into skin types? Let them make suggestions. One class did this on a basis of a freckle count!

Is there any connection between skin type and a tendency to sunburn? What happens when skin tans? Have they watch strap or sock marks giving opportunity for detailed observations? How many differences can they notice between tanned and untanned areas? Let them use a magnifying glass to look really closely.

Could they devise a fair test to judge the efficiency of proprietary sun-tan preparations. There's lots of scope for interesting discussion. Remember that over-exposure to strong sunlight can be harmful, but they could make use of normal contact with sun on a bright day, perhaps using their arms or legs.

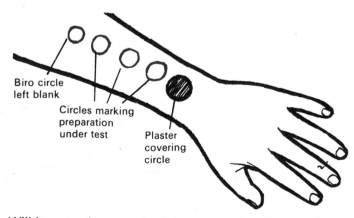

Biro circle left blank

Circles marking preparation under test

Plaster covering circle

Will it matter how much of the preparation they use?

Will it matter where they apply it, over what area, and for how long?

Will it matter which people, or person undertakes the investigation?

Will they need some untreated area (a control) with which to compare results?

Perhaps someone will put their ideas to the test.

Looking at hair

Again here is an opportunity to investigate colour distribution within the class (is this as easy as for eye colour?). Is, say, brown hair really brown? Let them explore with lenses, and if possible, a microscope.

A cardboard frame as shown below will make examination of individual hairs easier.

What can they find out about grey hair?

What can they discover about dyed and bleached hair?

Is it true that dyeing and bleaching makes hair weaker?

They will need to devise some means for measuring the strength of hair.

The hair of other animals is worth exploring. Encourage the collecting of information about animals that have different-coloured coats at different times of the year. This could lead nicely to investigational work on camouflage (see Index).

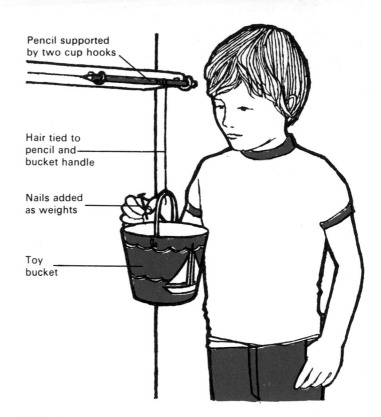

HOW STRONG IS HAIR!
We wondered how strong ordinary human hair was. and if there was any difference between different coloured hair, and between straight and curly. So we suspended a yoghurt carton by a hair and then we began to fill it by small spoonfuls of sand to see how much we had to put in to the carton before the hair broke. (They call this breaking - strain.)
We found there were differences between the different colours and sorts of hair. At least, in the ones we tried.

Pencil supported by two cup hooks

Hair tied to pencil and bucket handle

Nails added as weights

Toy bucket

Collecting colours

Collections are popular. They also promote discussion and provide a useful pool of shared experience from which other work may develop.

Plants and stones

Glass and liquids

Metals

Paper and fabrics

Colour lists

Why not list the colours inside the classroom and compare them with outdoor colours? Which is the commonest colour? Which is least common? Is this always so?

Inevitably there will be colours that are difficult to describe. The activity reveals the paucity of some children's colour vocabulary and at the same time provides an opportunity for improving it.

Perhaps the children could list phrases that describe colours . . . as brown as a berry . . . as green as grass. Are they good descriptions? They might also discuss and keep a look-out for appropriate descriptive writing.

Which are the children's favourite colours? Can they make a chart of their preferences? Will they get the same result in a week's time? Do older people have the same colour preferences? Which are 'nice' colours? Which are 'nasty' ones? Encourage discussion of ways of classifying colours. Here are some possibilities:

Happy colours

Fabric colours

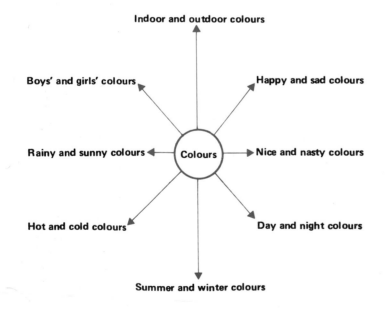

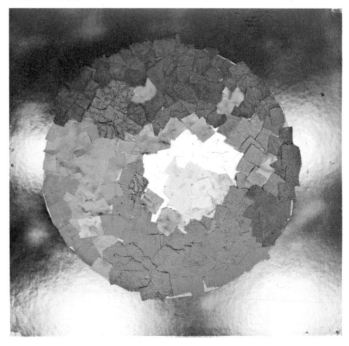

12

Colour corners

These are ever popular and a good source of material for investigational work.

One class of nine-year-olds decided that they would set up colour corners 'like we had in the infants, but with more to do'.

They organised themselves into groups, chose a colour for each group, and took over the classroom. The groups vied with each other to produce variety and attractive displays but within each group there was a great deal of co-operative effort. The blue group even arranged that on one day they would all wear blue clothes!

Of course their teacher was not redundant during all this activity. She was busy preparing for the things that might develop from the collections. Perhaps their new awareness of colour would sustain interest in colour mixing . . . perhaps the striking photo of a giraffe in the yellow corner might stimulate interest in camouflage . . . maybe their fascination for coloured Perspex would lead to work with coloured filters and perhaps stage lighting . . .

Special collections

After making random collections children often respond well to special challenges initially suggested by their teacher.

Try making a collection of things which are alike but which show wide colour variation. Flowers, paper, fabric, rocks are good things to choose from.

Try also a collection of things which on first thought are the same colour. 'Green' leaves, 'brown' soil are good starters.

Collections of this kind do much to increase children's general awareness of colour and can lead to further explorations, particularly those activities described on page 33.

Sorting colour collections

A collection of coloured things will inevitably get sorted. Much of the sorting will be informal and incidental to other things, as for example, the use of materials in collage work.

But there will be times when more formal sorting is possible. 'I don't want to use that. It's a nice colour but it's not shiny enough.' Remarks like this invite discussion of the total properties of objects and the various ways these properties combine.

Changing colours

Children at this stage will say something has *changed*
colour if what they are observing does literally become a
different colour. The subtleties of colour mixing theory
are doubtless beyond them, but on their own terms
they can have lots of experience with colour that will
help future understanding of difficult concepts.

Mixing paints

Children will have experience of this in their art work,
but many will enjoy the challenge of investigating colour
mixing in a more sustained and systematic manner.

How many different colours can they make from the
paints available to them? Let them experiment with one
colour and with black and white paint.

What colours can they make if they pair up colours?
. . . if they bring three colours together?

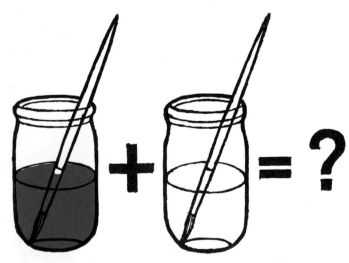

How many different, say reds, can they make?

What happens to a colour if it has increasing amounts
of water added to it?

Work of this nature will be accompanied by discussion
and the chance to introduce descriptive words to
distinguish between tone, hue and intensity of colour.

See-through colours

Exploring coloured transparent materials
Provide transparent coloured materials including:
sweet wrappings, coloured glass, coloured Perspex.

Coloured acetate is also useful, if expensive. It's stiff
enough for easy handling, and children enjoy making
colour viewers.

The viewers might be held in the hand.

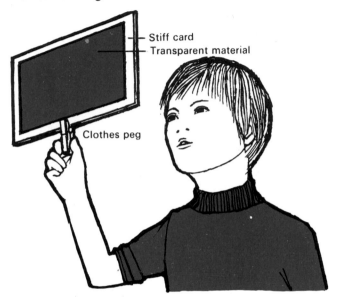

Stiff card
Transparent material
Clothes peg

Or worn as specs.

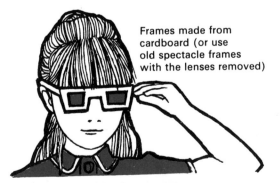

Frames made from
cardboard (or use
old spectacle frames
with the lenses removed)

What happens when children look through their viewers
at various coloured objects? Is there a colour change?
Which changes are most noticeable?

The value here is in finding whether there is a change, not in trying to explain it. Sweet papers and cellophane will produce results that may not seem 'right'.

Exploring coloured solutions
You can make a good range of coloured solutions by using inks, liquid dyes and food colourings. It is best to provide them in flattened bottles that can be handled easily.

Let the children hold up the bottles to the light and see what happens when they overlap two different solutions. One effect can be seen in the photograph on page 17. Explore also the effect of looking at different colours through the solutions.

Coloured light
Let the children find a dark corner and explore the effects of coloured covers over torch lights. Pencil beam torches are good. Perhaps they can also bring in torches that are designed to give red or green beams.

What do they notice when they shine different colours on to different coloured paper? (Sugar paper supplied in spectral colours is useful.)

Investigating spectra
Can we get colours from sunlight? Many teachers, and children too, will be familiar with rainbow colours seen in particular situations, as when sunlight hits a glass of water producing a spectrum on the wall.

Some may know that such a spectrum can be obtained by using a prism. There are other ways such as the one shown at the top of the right hand column.

Encourage observations and talk about the colours they see. Can they make the different coloured bands smaller? Can they make them bigger? What happens when they look at their spectrum through coloured transparent things?

Can the children colour sunlight?

Some might like to construct a colour box in which different coloured objects can be made to change colour by using coloured filters. They may come up with ideas: here's one shown on the right.

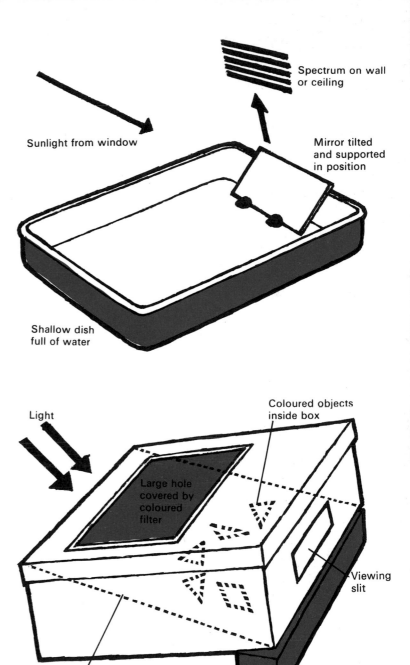

Sunlight from window

Spectrum on wall or ceiling

Mirror tilted and supported in position

Shallow dish full of water

Light

Coloured objects inside box

Large hole covered by coloured filter

Viewing slit

White card fixed diagonally inside box

Investigating stage lighting

Discussion of stage lighting is appropriate to any work on changing colours. Some children may have experience of various lighting effects: some might bring back observations from a theatre visit.

Perhaps the class could light a puppet theatre? They could prepare a backcloth (paper on paper, paint on paper or fabric, fabric on fabric) and light it with the beam of a daylight projector. Coloured acetate filters placed directly in front of the projector lens will change the appearance of their backcloth.

Can they prepare a scene that will change from day to night just by changing the filters? What effect will this have on the puppets' costumes? There should be lots of exciting possibilities here.

Colour filters here

They might also explore the theatrical effects of using back projection to beam coloured light on coloured materials arranged on a suitable transparent screen.

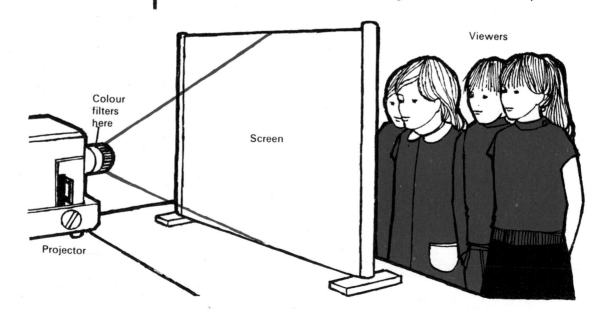

Colour filters here

Screen

Viewers

Projector

Incidentally if you have a projector available try making some colour mixing slides.

You will need some 2×2 glass photographic mounts and some coloured cellophane.

Stick a small piece of cellophane on the mount with clear adhesive and overlap it with another colour.

Put the glass mount in the projector's slide attachment and direct the beam on to a screen.

If you crumple the cellophane first you will get some gorgeous patterns, besides noticing colour change effects.

Will these effects be the same as for overlapping coloured solutions?

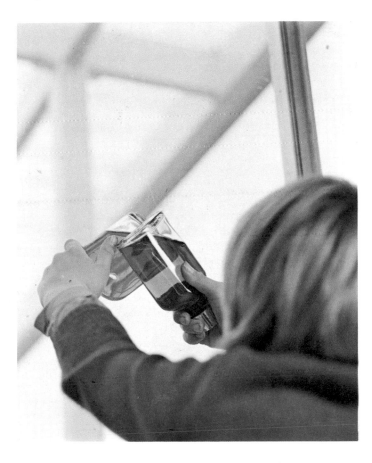

Colour wheels

One ten-year-old made a study of the colour changes he noticed when various discs that he had prepared were rapidly spun round using an electric motor. Some of his findings are shown in the photograph below; the apparatus he devised is shown on the next page.

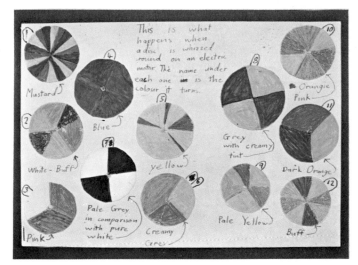

1. The green and red combine to give yellow
2. Red, green, and blue, yellow, and the mauvey colour in the top right hand segment are mainly the colours of the rainbow so that is probably the reason why the basic colour is white.

3. For some reason the brown is ignored. This may be because brown is not a member of the spectrum.

Coloured spinning discs are fascinating. Children can enjoy them and make profitable observations, but the emphasis at this stage should be on noting what happens, not trying to explain it. The traditional Newton's disc by which a disc of spectral colours is spun to give a white appearance is seldom successful when made from ordinary classroom materials.

Let the children experiment with their own colour patterns.

Try using a gramophone turn-table

Paper disc with colour patterns

or more simply a strip disc.

They could also devise their own spinning disc powered by a Meccano motor from a model shop.

The diagram below shows the apparatus constructed by the ten-year-old whose work is illustrated on the preceeding page.

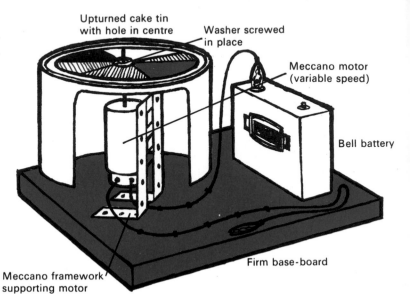

Upturned cake tin with hole in centre

Washer screwed in place

Meccano motor (variable speed)

Bell battery

Firm base-board

Meccano framework supporting motor

In any work with spinning discs it is useful to get the children to organise their findings in some way. They could, for example, group together discs that show very marked changes distinguishing them from those that don't. They might also try to predict what will happen, recording first their predictions and then what actually happens. This is valuable experience but explanations of their findings are best left to a later stage.

3 Park and country colours

If children are to investigate park and country colours they must get out among them. There is a lot of interest awaiting; let us look at some possibilities.

Observing animals

Animal colours will be only part of children's interest in any creatures they discover. But some observations invite development.

Looking at birds
How many different coloured birds can they notice? Which is the commonest colour?

There may not be a great number to be seen on an excursion, for a class of busy children scarcely provides conditions conducive to bird-watching! Why not set up a bird-table at school? Here's a simple one.

Put the bird-table somewhere where there isn't too much activity. A sheltered corner will encourage 'timid' birds, but make sure it's out of cat-springing distance.

Let the children keep a log of the visitors. They will want to make lots of observations of bird behaviour; some may involve colour.

Can they classify the visitors by their colours?

Is there any connection between the colour of birds and their size?

Is there any connection between the colour of birds and the particular way they move?

Are, say, blackbirds really black?

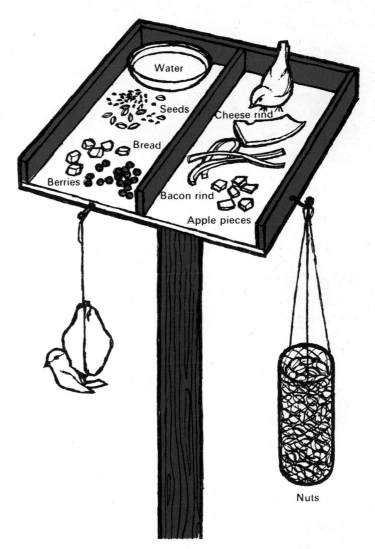

For birds of the same kind, is there any connection between their colour and their age? . . . their sex? . . . the season?

The children's observations will need to be supplemented by information from books.

Make a collection of bird feathers. Look closely at the colour variation in individual feathers, and the range of colour in the feather-covering of one bird. Stuffed birds can be helpful here although a 'real' one is better. Perhaps there is a local pigeon fancier who could bring birds for the children to examine and talk about; perhaps someone has a chicken that needs plucking.

Can birds see colour? Encourage discussion of ways of investigating the problem. The children might try adding bird-food to their bird-table in different-coloured dishes; they might try other things. But they will need to discuss whether or not they are conducting a 'fair' experiment. Have they thought out all the things that might influence the bird's behaviour? For example, a bird might be attracted to a particular colour dish because:

It is most easily accessible.

It contains particularly choice food.

Its size makes it more obvious.

Its shape makes it easiest to feed from.

Let them discuss these things and find ways to keep all such varying possibilities identical for each colour. They will then be investigating in a 'fair' manner.

The photograph below shows the work of children at an early stage in appreciating the variables involved.

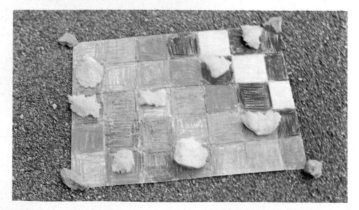

Looking at minibeasts

There is a Project Unit called *Minibeasts* containing suggestions for working with snails, worms, spiders, beetles and other insects. Animals such as these will certainly be discovered on any outdoor trip and in *Minibeasts* you will find details of where to look for them, how to collect them and how to look after them. Here we will consider a few activities relating to their colour.

Can the children find red minibeasts? . . . yellow? . . . green? . . . white? . . . black? . . . brown?

How many can they discover that have two colours, three colours, etc?

What colour differences can they find in animals of the same kind? Ladybirds are good subjects to investigate.

How many animals can they find that are difficult to see against their background? What are their enemies?

Can they find insects that are easy to see when moving but not easily seen when at rest?

Can they find brightly coloured insects that are easily seen when resting? Have these enemies?

Can minibeasts distinguish colour? This is a challenging question calling for discussion about the design of a fair test.

Investigating camouflage

Studies of animal colourings are almost certain to include work on camouflage. It is a popular topic offering great scope for practical investigation.

Encourage all kinds of explorations of the interaction of local colour (the colour of objects) and background colour. With practical experience children soon appreciate that colour alone is not an adequate camouflage; pattern and form are also seen to be important considerations.

Using 'Action Man'

Many children will be familiar with the military use of camouflage. Perhaps someone can bring an 'Action Man' to school with a full range of combat suits. Encourage talk about the places where each suit is appropriate. Perhaps someone could search for illustrative pictures or produce appropriate paintings.

Try also to extend discussions that lead to quantitative investigation. The children might look for places around the school where 'Action Man' is easily seen from a distance of, say, 100 paces, and places where it is difficult to see him against his background. Which background makes the best camouflage? How will they devise a fair test?

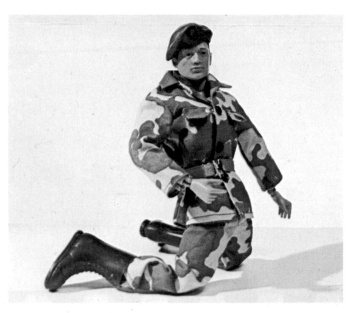

Their testing with Action Man might lead them to investigate effects in other animals.

Others might like to research details of past military uniforms to discover how adequately the men were camouflaged from the enemy.

They will find many that were most inadequate for concealing the wearer. Had the colour of the uniform some other function?

Using model aircraft
Could the children paint model aircraft so that their visibility is reduced when seen from above and when seen from below?

What is the best camouflage for aircraft on a concrete landing strip? . . . on a grass landing strip?

Here is one boy's investigation:

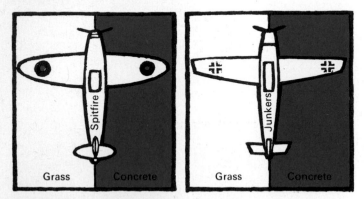

He painted the aircraft authentic colours and tested them against painted backgrounds. His findings are shown below:

No. of paces	Grass: Visibility		Concrete: Visibility	
	Spitfire	Junkers	Spitfire	Junkers
20	√	√	√	√
30	√	√	√	√
40	√	√	√	—
60	—	√		

Notice the effort to produce quantitative results. He has systematically observed the aircraft at different distances and for each has recorded whether or not it was visible. How might he have made his findings more objective? Could anyone devise a scale of visibility for use in such an investigation?

Some girls respond well to work of this nature but many have little enthusiasm for such 'boys' stuff'. They might enjoy activities with a more feminine appeal. Could they, for example, construct a dolls' house or a room whose door, or some other feature, is disguised?

Looking at mammals
On most outdoor trips children will encounter a mammal. It might only be an 'ordinary' domestic dog or cat. But it's worth looking at for all sorts of reasons. As far as colour is concerned, how does it compare with that of the children's pets?

Can different breeds of cats and dogs be distinguished by colour alone?

Can cows, sheep, horses . . . be distinguished by colour alone?

What happens to their colour when animals are 'cross-bred'?

There is scope here for considerable reference work.

Perhaps the children will be lucky enough to encounter wild mammals.

Are they the same colour all over?

Does their coloration make them easy to see or difficult to see from a distance?

Does their colour appearance alter when the animal is resting or on the move?

There are many first-hand observations to be made, and discussion will likely turn to talk about camouflage (see the subject index). Don't forget also that the children themselves are mammals (see Chapter 2).

Looking at fish
Have a look at fish in ornamental ponds and clear streams. Are they easy to see when looked at from above? Would they be seen so easily if looked at from below—or sideways? Children could investigate this in their classroom.

Don't forget the fishmonger's: it is a good source for observations. Can someone make a visit and report back? They will find out about the colour and shape of different fish.

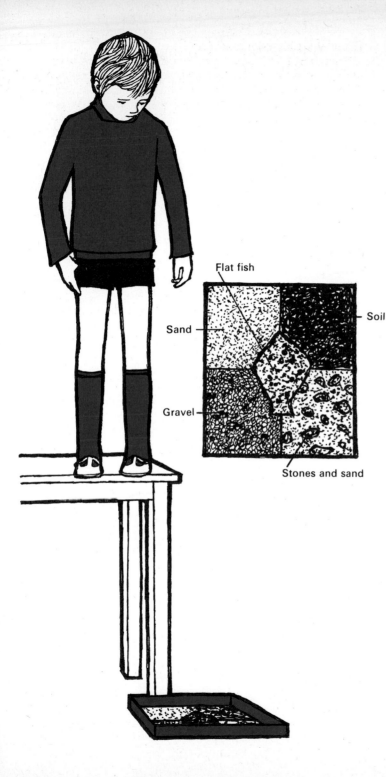

Flat fish

Sand

Soil

Gravel

Stones and sand

Is there any connection between colour and shape? Let children examine say a herring and a flat fish (eg sole, plaice), and compare their colours. Incidentally herring scales will get everywhere and can smell horribly in time. So keep the fish for handling in a flat tray that can be easily scrubbed. But take advantage of the fact that the scales rub off easily. The children can examine the coloured effects as they 'catch the light'. They're also worth looking at under a microscope.

Flat fish generally live on the sea bottom and are well camouflaged from above. Some children might like to investigate the animals' visibility against different backgrounds.

Let them try various materials for the 'sea bottom'.

Which makes the fish disappear most?

Can they make a background against which the fish completely disappears?

What happens if they turn the fish over?

Two boys working on the problem devised the following method for investigating visibility against different backgrounds.

After considerable exploration they made a completely merging background. How might this be developed into a *quantitative* investigation?

Of course not all fish merge with the background of their natural environment. Tropical fish are a case in point. Although some have vivid colours forming an effective camouflage, others have brilliant colours that draw attention to themselves. In these fish, the distinctive colouring is usually accompanied by some nasty habit and other animals seeing them are warned off. The vividly spotted trunk fish, for example, can discharge a poisonous fluid.

The subtleties of colour adaptation are beyond children at this stage, but they will gain much from discovering what a wide colour variation occurs. Perhaps someone's father keeps tropical fish? Maybe there is a local well-stocked pet shop? Certainly a zoo visit provides fascinating material for observation.

Visiting the zoo

Include work on camouflage in any visit to a zoo. Try to provide pictures of the natural environment of the animals the children will see and encourage comparative observations of their housing in the zoo.

How far has the zoo created a 'natural' environment?

How would the children improve things, given the chance? Some might later make a 'mock-up' of their suggestions using model animals and junk materials.

Zoos, of course, provide marvellous opportunity for detailed observation of animal colours. There are the bright vivid colours of the aviaries and tropical aquaria; there are colour patterns of the larger animals to be noticed. And don't ignore the Reptile House where there are interesting camouflage colours to be seen. There may also be a chameleon and opportunity to observe a remarkable colour change.

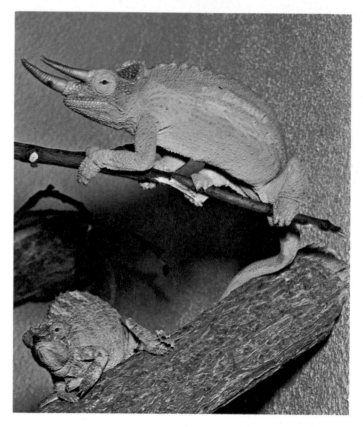

The chameleon really is a fascinating animal and well worth reading about. Its colour changes are caused by the contraction and expansion of pigment spots in its skin.

Perhaps someone would like to find out the names of other animals that can change the colour of their skin.

Try discussing with the children why they think the animals have this particular ability and help them appreciate that it has a protective function.

Can anyone think of a situation in which he would like to be able to change his skin colour? Such thoughts could lead to interesting, imaginative writing.

If possible, explore colour changes in a live frog. Keep it in a dark container for a couple of days, transfer it to a light background and it will virtually change colour while you wait. The effect, as in a chameleon, is caused by changes in the pigment cells of the skin as shown below.

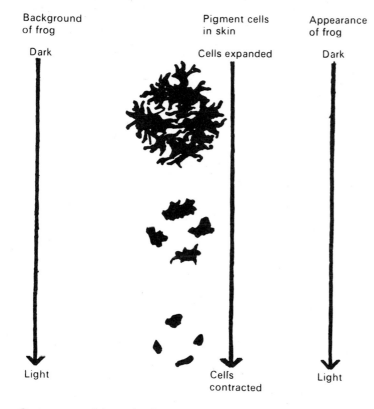

Background of frog

Dark

Light

Pigment cells in skin

Cells expanded

Cells contracted

Appearance of frog

Dark

Light

One group of boys intrigued by this change wondered if the colour of the surroundings of frog spawn would affect the colour of the tadpoles that hatched from it. They rigged up a number of containers for the eggs (including one with red and white stripes) and waited to see what happened. They didn't get candy-striped tadpoles, but they did get interesting results.

When children's imaginations are given free rein on a problem, they come up with all kinds of ingenious suggestions which are fun to carry out, and nine times out of ten they provide good learning situations.

Let them imaginatively explore the topic of animal camouflage. They'll have fun making improbable model animals and trying to devise effective concealing backgrounds for them. At the same time they will unobtrusively gain experience of interactions of colour, pattern and form in living things.

Disappearing boxes
When the children have had fair experience of camouflaging familiar things, try giving them the challenge of making boxes disappear.

Provide large cardboard cartons and a limited range of emulsion paint. Make sure that the boxes initially stand out very obviously from their background; they may need some preliminary painting. Don't forget to keep one box uncamouflaged so that the children can compare the before and after effects of their work. Choose some well-defined background for the challenge, such as a brick wall, vertical railings or a dappled bush.

It is important that each box remains in, or is returned to, the same position when the children are working on it and that they are quite clear about the place from which it is to be viewed. Discuss with them the need for these measures if the results are to be fairly judged. It is good experience of thinking about controlling things that vary in a situation. It is worth while also encouraging them to talk about things that might affect their results that cannot be controlled. For instance, the sun moving behind clouds and so altering the appearance of the box. In this way they can narrow their problem and cope more adequately with it.

After such experience the class might apply their skill to some useful project. Perhaps they could make a camouflaged hide from which to observe birds. Perhaps there is some tatty area around the school that could be effectively camouflaged. Experience with inanimate objects will give them greater insight into the nature of animal camouflage, and work may well lead back to living things. Could they, for example, camouflage themselves?

Observing plants

A lot of colourful plant material finds a home on the Nature Table, and through collecting and arranging leaves, fruits and flowers, children become increasingly aware of the variety of plants and their seasonal changes.

Here we shall consider how such general experience can be extended. We shall look at some ways by which an interest in coloured plants can lead children to search for connections between isolated observations, and to carry out investigations.

Looking at flowers

Let's start with flowers. Make a survey of flowers growing in various places: in local gardens, in the local park, on waste land, on roadside verges, in pasture land.

What is the commonest colour?

Is it the same for cultivated and wild flowers?

Will the findings be the same at all times of the year?

Which particular flowers show the greatest range of colour?

The children might be introduced to the idea of family likeness in flowers. Start with some easily recognisable families.

Why not sow a packet of quick-growing annuals of mixed colours? Nemesia is a good example.

What colours appear?

How many of each?

Would they get the same results from a second packet?

Would they get the same colours if they collected the seed and sowed it for next year?

Encourage discussion about the colour of flowers and their scent.

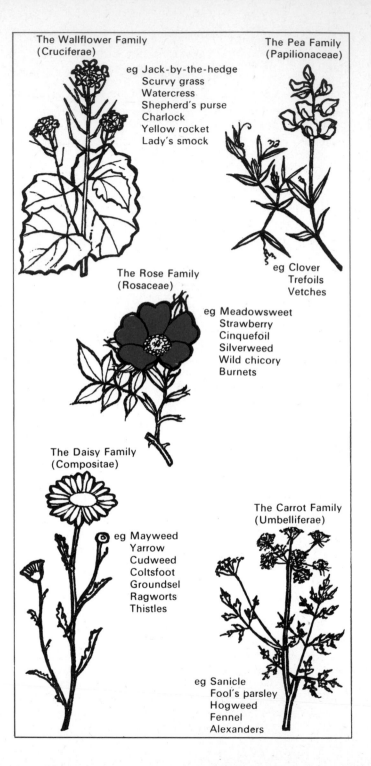

The Wallflower Family
(Cruciferae)

eg Jack-by-the-hedge
Scurvy grass
Watercress
Shepherd's purse
Charlock
Yellow rocket
Lady's smock

The Pea Family
(Papilionaceae)

eg Clover
Trefoils
Vetches

The Rose Family
(Rosaceae)

eg Meadowsweet
Strawberry
Cinquefoil
Silverweed
Wild chicory
Burnets

The Daisy Family
(Compositae)

eg Mayweed
Yarrow
Cudweed
Coltsfoot
Groundsel
Ragworts
Thistles

The Carrot Family
(Umbelliferae)

eg Sanicle
Fool's parsley
Hogweed
Fennel
Alexanders

Is there any connection between the colour of flowers and their smell?

Do brightly coloured flowers smell more strongly than others?

Do all, say, yellow flowers have the same scent?

Can children classify different scents? What words best describe different scents?

Talk also about flower colour and shape. Is there any connection between the colour of flowers and their shape? The children can discuss different flower shapes and perhaps arrive at some working classifications.

Which flower colour has the greatest range of shapes?

Can any one remove the colour from coloured flowers? Encourage free exploration. Try using a range of solutions, including water, white spirit and vinegar. With some flowers, particularly blue and red ones, they might get surprising things happening.

If you have a range of flowers available have a look at their pollen. Try 'dusting' it on to paper and later examining it under a microscope. It will make interesting patterns.

How many different colours can the children discover?

Is there any connection between the colour of pollen and the colour of the flower it comes from?

Is there any connection between the colour of flowers and the kind of insect that visits them?

Do certain insects 'prefer' particular colours of the same kind of flower?

If flowers are not readily available why not grow some? For long-term benefits it is a good idea to make a colour garden. Discuss the possibilities with the children. Perhaps part of a school border could be used, or flower-pots sunk in peat in an old tub or trough. Aim for a range of coloured clumps including weeds which, in addition to visual appeal, will provide good material for general observation and dyeing (page 52).

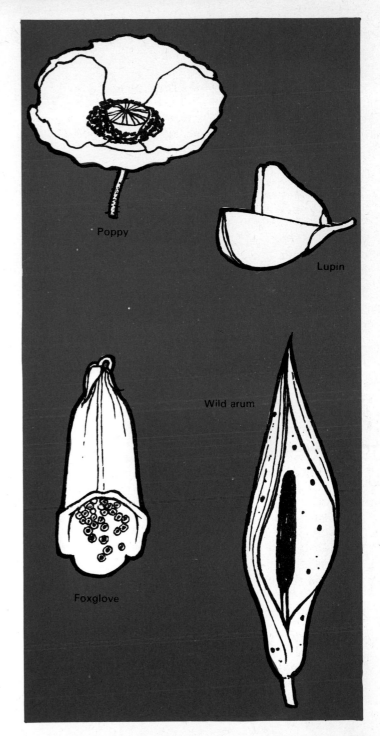

Poppy

Lupin

Wild arum

Foxglove

Coloured pollen was the stimulus for this ten-year-old's painting

Looking at plants without flowers

Plants without flowers have good potential. Try a hunt for the small flowerless plants that children normally group together as 'mosses'.

Mosses

Mosses are difficult to name individually but this shouldn't deter collections. One group of ten-year-olds got fifteen different kinds from a local wood and they were amazed that such 'ordinary things' could show such interesting different greens when gathered together. They became the moss experts of their class and distinguished each kind by invented names such as 'the pin cushion, the spiky one'.

During their observations one boy noticed that the moss changed colour as it dried up. He then set out to record how the colour changed as the moss lost water. He recorded the colour change by colour matching and the water loss by weighing against paper-clips.

Lichens

Lichens show an interesting colour range. They will be found on old buildings and tree trunks and they make good dyestuffs (see page 52). Lichens are extraordinarily difficult to name but a useful working scheme is to name them by type:

Which type has the greatest colour range?

Which is best for dyeing?

Can anyone find a lichen that changes its colour when the weather changes?

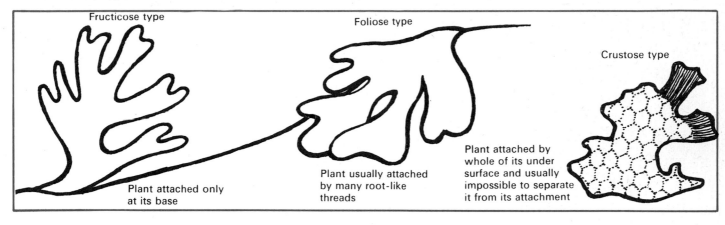

Fructicose type

Plant attached only at its base

Foliose type

Plant usually attached by many root-like threads

Crustose type

Plant attached by whole of its under surface and usually impossible to separate it from its attachment

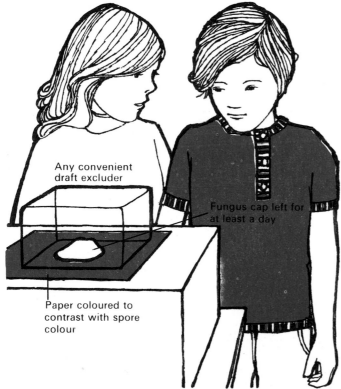

Any convenient draft excluder

Fungus cap left for at least a day

Paper coloured to contrast with spore colour

Mushrooms, toadstools, moulds

Fungi also have a good colour range and it's fun to go on a fungus hunt in autumn. But remember that a few are poisonous, and the children should be taught to recognise them.* They should wash their hands after handling any fungi and never taste them.

Why not make a collection of coloured spore prints? It's an easy task and in carrying it out other discoveries will be made.

If an interest in fungi develops some children might like to grow their own moulds. Try bread, apples, jam under transparent containers in a warm place. Who can get the most colourful mould garden?

Which colours appear first?

Do they change in time?

Do they change if the moulds are kept outside?

* *See P. North*, Poisonous Plants and Fungi, *Blandford;* Edible and Poisonous Fungi, *Bulletin no. 23, HMSO; Ramsbottom,* Poisonous Fungi, *King Penguin.*

Seaweed

If the children are fortunate to live near or can visit the seaside, be sure to examine the seaweeds as part of all the exciting activities that the coast has to offer.

How many different colours can they find?

Is there any connection between its colour and its place of growth?

On a rocky shore a well-marked colour-zonation of weed will be noticeable.

Can they map the distribution of the different colour types?

Which colour is commonest?

Is it the same at different times of the year?

Colours down the shore

High tide

Mainly green weeds

Mainly brown weeds

Low tide

Mainly red weeds

Channelled wrack

Flat wrack

Knotted wrack

Serrated wrack

Bladder wrack

Thongweed

Looking up and down

There are lots of possibilities for observational work here.

Looking at the sky
Encourage records of sky colours. What changes occur during a day? What changes occur during a week? Can the children use their observations to predict any future events?

Are sunrise colours the same as sunset colours? Is it true that a red sky at night is a sign of fine weather to come?

How many cloud colours can the children notice?

Are different-coloured clouds different shapes?

Are fine-weather clouds different in colour to wet-weather clouds?

Some might like to paint cotton-wool clouds to record their findings.

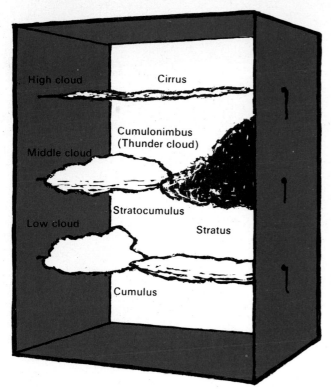

High cloud — Cirrus

Middle cloud — Cumulonimbus (Thunder cloud)

Stratocumulus

Low cloud — Stratus

Cumulus

Finding rainbow colours

Are rainbows always the same colour?

Where are rainbow colours found? Some will have noticed them on roads and puddles. Could the children make some rainbow colours in the playground? Try using a small amount of petrol on damp dark tarmac.

What happens to the colours if they add more water? . . . if they add more petrol? . . . oil? . . . other things?

What happens if they walk through the colours?

In any discussion of rainbow colours, talk about bubbles and rainbows from glass is almost certain. Let the children explore freely with these materials. Observations of bubbles are particularly exciting and provide marvellous opportunity for vocabulary building. Lux liquid makes good bubbles.

What colours can children notice if they look at a bubble in sunlight? Do they change at all?

Do bubbles made from different things have different colour patterns? Try different soaps and various detergents.

Do big bubbles have different colour patterns from small bubbles?

Do different-shaped bubbles have different colour patterns?

It's a difficult task to make different-shaped bubbles. Have they ideas? Wire bubble frames will help.

We blew bubbles We
Saw all the colours of
the rainbow in them
The longest bubble
floated for 26 seconds
the shortest bubble
floated for 2 seconds

Sometimes a bubble
didnt start some
bubbles went nearly
to the ceiling

mentioned here to provide suggestions for development should the right occasion arise. This is particularly true of the next section.

In search of changing colours

The sun makes People they change brown change colour or red into

Examining soil

Is soil the same colour all the way down? If possible let the children dig a really deep hole to investigate.

How many colour differences can they notice?

Are the different-coloured parts also different in other ways?

Will the colours they notice stay the same after a day?... a week?... a month?

How many different-coloured surface soils can they collect in the locality? Perhaps children going on holiday can bring back other soils to add to the collection.

Are the different-coloured soils equally good for growing seeds?

In work of this nature, as in other places in the Unit, investigations of the colour of things are likely to be incidental to other lines of inquiry, but they are

Adopt a detective approach.

Look at the local building stones and bricks. Are they the same colour as when the buildings are new? Scraping with fingernail or penknife will help children decide.

Are there any metal things around that have rusted or changed colour in other ways?

Are there dead or dying plants to be seen? Is there a rubbish tip or compost heap that can be examined?

Who can find examples of faded paint and faded fabric?

Can anyone find places where water has made things change colour?

Are there signs anywhere of fire and fire-changed colours?

Do any of the colours around seem to change in sun and shade? Can some keen-eyed person find shadows that change colour?

For some children collecting and perhaps recording observations is sufficient. Others may go further. For these children profitable lines of inquiry might involve:

1. Extending their experience of particular changes. For example, they might notice several metals that have changed colour.

Do all metals change colour when left out of doors?

Do some metals change colour faster than others?

The children can discuss and devise ways of finding out.

2. Investigating patterns in colour changes.

Are the colour changes they notice more obvious in some places than in others?

Are conditions in places where change is very noticeable in any way different from those of unchanged areas?

Is there perhaps some connection between the amount of change that occurs and other things in the surroundings?

These are sophisticated questions but ones which will give rise to good discussion.

The emphasis here is on making and connecting observations. *Why* things change colour requires too complex an answer, but it's worth while discussing how long they think the changes took to happen. A crop of varied opinions is likely. How might they check their ideas? They might also discuss whether or not it is possible to regain the original colours and perhaps put some ideas to the test.

Don't forget also the big-scale colour changes out of doors. Have a good look at the over-all colour of the landscape. There is opportunity to talk about town and country colours, their seasonal change and 'moods'. Children might produce paintings that record their present colour impressions and records also that predict the colours of coming seasons. How good are their predictions? Their paintings can be examined later in the light of what actually occurs.

Here is a teacher writing about her class of eight- to nine-year-olds after some work stimulated by a colour hunt.

'The children are very much more aware of colour now, they mix paint more readily and enjoy making and using suitable colours. Water is not always blue; when they painted a beaver river it was brown. Shadows are not always black as they thought. They made footprints in the snow a bluish colour and tree shadows are a darker shade of the colour they fall on.'

These children through observation and activity have clearly acquired a greater awareness of colour.

4 Street colours

Most of the suggestions in this chapter are particularly relevant to urban environments, but many are also appropriate to less hectic country streets. Equally, a number of the activities outlined in the previous chapter apply as easily in streets as in parks and gardens. Let's consider some possibilities.

Observing traffic

Looking at cars
Many simple observations can lead to experience of organising data and critically interpreting findings.

What, for example, is the commonest car colour? The children in one class discovered a preponderance of red cars and advanced a theory that this was related to the fact that red was the colour of local football clubs!

Is there any connection between the colour of cars and the year they were produced? Did, for example, more people buy black cars ten years ago than they do today?

Car parks with large numbers of cars with year-dated registration plates are good sources of information here and the children can profitably discuss the reliability of their findings.

Collect some manufacturers' pamphlets of car colour samples.

Which colour would the children choose?

Would it be a safe colour?

Which colours are most easily seen?

Can they establish an order of visibility for different-coloured cars?

They could carry out investigations in a busy straight road, a motorway footbridge would make an excellent vantage point, or they might use model cars outside.

At what distance can they no longer make out the car colour?

Is it the same for all colours?

Will they get similar results with cars on tarmac, and on grass?

How accurate are their results? How can they prevent cheating? Here's good opportunity for devising controlled investigations.

Will they get the same order of visibility at dusk?

Observations of real situations are valuable but not often practicable. How could they simulate dusk conditions? Could they construct a 'mock-up' to investigate car colours in different light intensities and so have experience of using representational models to investigate problems or relationships. They might work with strong natural light from a window, examining the cars in full daylight and then gradually cutting down the amount of light by using some suitable screen. Try polythene, tissue paper and other things.

They could also make a 'dimming box' lit by artificial light. Provide bulbs, batteries, bell-wire and large cardboard boxes and let them explore freely; there is much scope here for ingenuity and no 'right' way of devising suitable apparatus.

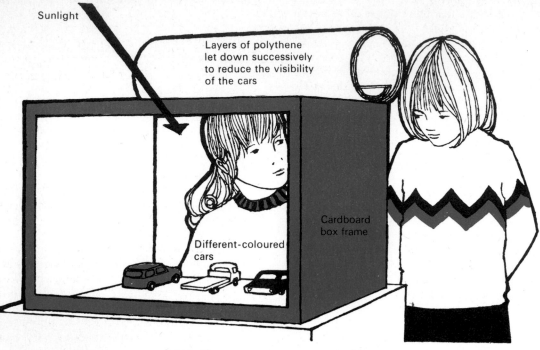

Sunlight

Layers of polythene
let down successively
to reduce the visibility
of the cars

Cardboard
box frame

Different-coloured
cars

Most children will find it easy
enough to light a box. But dimming
it is another matter. One group
of boys attempted to do this by
covering the bulbs with different
materials, having discussed with
their teacher the fire risk involved
if they worked with stronger lights.

Here are their findings.

'We used different materials to dim
the bulbs. We gave the brightest
bulb ten points and the dimmest no
points. We put the others in between.
This is what we discovered.
See block graph on right.

Significantly they end their record:

'Our results are not really accurate
because we couldn't measure the
brightness. But we got them in the
right order.'

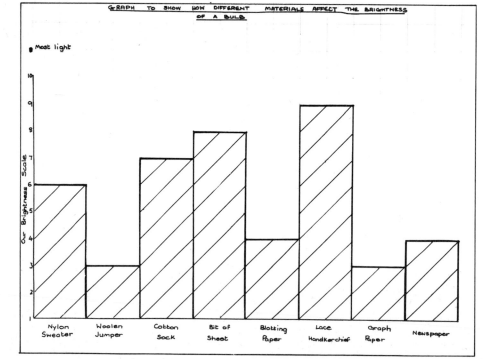

GRAPH TO SHOW HOW DIFFERENT MATERIALS AFFECT THE BRIGHTNESS OF A BULB

Most light

Our Brightness Scale

Nylon Sweater · Woolen Jumper · Cotton Sock · Bit of Sheet · Blotting Paper · Lace Handkerchief · Graph Paper · Newspaper

36

Looking at street lights

What happens to daytime colours when they are seen at night by different kinds of street lighting and neon signs? Has anyone noticed any colour changes? How could they discover which colours do change? Encourage discussion of the problem. It's a simple one for adults but not so easy for children. They will probably end up with a multicoloured collection of things for a volunteer, perhaps their teacher, to observe. If their collection is a random one they may find some surprising results. Once they have identified things that show a marked colour change other things are possible.

In one school some individuals incorporated the materials into 'magic scenes' to surprise their parents.

Others, intrigued by their findings, might go further and make colour boards for more systematic investigation. Provide a range of coloured paper (matt paper supplied in 'spectral' colours is best) and encourage discussion of ways of planning boards for reliable and easy use. Here is one pattern.

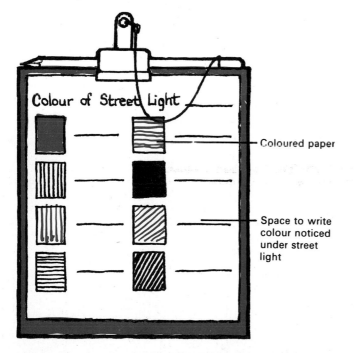

Colour of Street Light

Coloured paper

Space to write colour noticed under street light

When the children have recorded their street light observations, help them to organise their findings.

Here's a scheme produced by able ten-year-olds:

Colour in daylight	Colour when seen under different street lights		
	Yellow street light	Blue street light	Red street light

If you have some children conveniently able to explore the effects of street lighting, do encourage them to look closely at shadows and report their findings to others in the class.

What colour shadows can they find of objects lit by different kinds of artificial light? How do these compare with the objects' daytime shadows? Explanations are not appropriate at this stage: sufficient that the children are building up ideas that the colour we see when we look at an object has something to do with the nature of the object and the nature of the light falling on it.

Looking at road signs

Encourage observations of traffic signs. What colours are used? Are they good colours for conveying a message? The children might look at particular warning signs, such as the one for an approaching cross roads and see if the colours used are efficient ones.

One group of boys engaged in this task made a dozen life-sized replicas out of stiff card and painted each in a different colour combination as shown in the photograph on page 40.

They then investigated the comparative visibility of each sign.

Anxious to achieve a 'fair' result they decided that they would not themselves be good judges of the signs effectiveness. They already knew the colours used and as one boy said: 'I'd like the one I made to win so I might cheat.' So they decided they would get children who had been working at other tasks to help them. Next they had to work out a plan of campaign.

It consisted of one boy holding up the signs in turn in a prearranged order whilst another stood with a volunteer who had to write down the colours as each sign appeared. In this way, using a number of volunteers, they were able to arrange the signs in order of colour visibility. Then, and only then, did one of the group suggest that the shape of the coloured parts might also be important in deciding how visible the signs were, and immediately they were off planning further work to put this suggestion to the test.

Work of this nature will involve discussions about the effect of background colour on the visibility of coloured things and can stimulate further activity.

Will the colour of an object appear to change if it is seen against different-coloured backgrounds?

Let the children suggest ways of investigating this. They might stick, say, red-coloured paper on a range of different colours,

or use different colours on the same coloured background.

See also the photographs at the top of page 40.

Are some colours more affected by background colour than others? Can they make a fair test? Some children will observe that the texture of surfaces affects the way we see colours and might pursue this further. They could, for example, select a particular colour and investigate its appearance on a range of surfaces. But let us return to traffic signs.

Provide some copies of the Highway Code so that children can gain information about the colour coding of various road signs.

Let them carry out a survey of signs in the neighbourhood.

Which kind is commonest?

Are the signs well sited?

Hunt for other 'official' signs. Do they show a good use of colour?

Some might like to design an easily visible wordless sign for conveying a message in school. What about a 'no running' sign for the corridor?

What might these be?

What other examples of colour coding of information can the children discover?

Look at the coloured wiring of electric plugs.

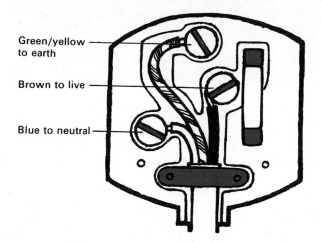

Green/yellow to earth

Brown to live

Blue to neutral

Search for colour coding in maps, and the use of coloured tags to denote clothes sizes. Has anyone noticed the strips of colour used by British Rail to indicate different functions of railway carriages? Don't forget coloured lights. Traffic lights and navigation lights on ships and aircraft are common examples. What are their messages? Perhaps the children would like to colour code information about themselves.

Looking at traffic lights
Traffic lights are well worth investigating.

What exactly is the sequence of colour?

How long does each colour last?

Is it the same at all crossroads?

A group might investigate some busy light-controlled intersection. Here's great opportunity for co-operative work. Could they record the colour changes and the length of time each colour operates and display their findings for others to see?

Initially they could time the sequence of each set of lights separately recording a number to allow for errors. Then they would need to obtain a simultaneous record for both sets of lights and find ways of presenting their results for comparison. For instance:

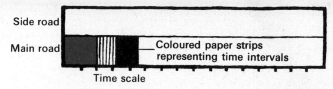

Side road

Main road

Coloured paper strips representing time intervals

Time scale

The children might use their findings to investigate aspects of road safety. For example:

How long is the time interval between amber on one set of lights and green on the other?

How far could a car . . . a cyclist . . . a pedestrian travel in this time?

Perhaps some would like to make a working traffic light. They could use simply three torch bulbs in holders, each coloured by sweet-paper and connected to a battery with an on-off switch.

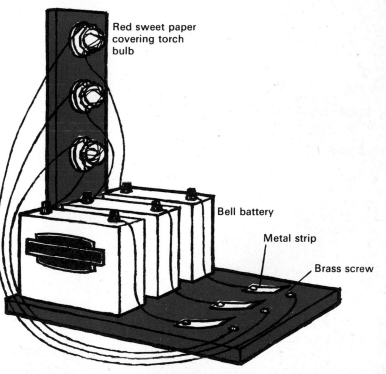

Red sweet paper covering torch bulb

Bell battery

Metal strip

Brass screw

Some might then attempt a 'Mark II' model. Can they discover how to operate the three bulbs using only *one* battery and a suitable switch?

Which circle is the hardest to see?

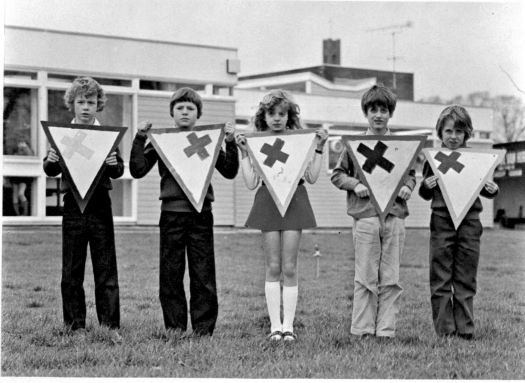

Testing the visibility of road signs. See page 37

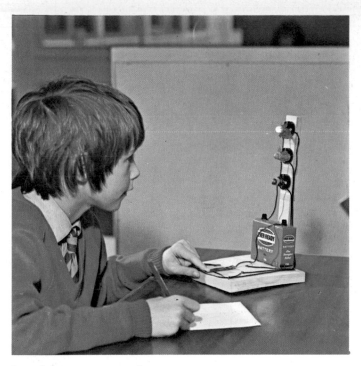

Looking at people
What is the commonest clothing colour?

Does this change when the weather alters?

Is there any connection between people's colour choice and their age? They will have to find some way of assessing age because all adults are 'old' to most children.

Is anyone wearing safety clothing? Try making a collection of pictures and observations of safety colours in use.

What can the children do to make themselves more conspicuous in reduced light conditions? Could they devise an experiment to find out which outdoor garment is easiest to see at dusk? How efficient are materials such as 'Dayglo'?

They might use themselves for experiments or make clothes for 'Action Man' or 'Barbie' dolls. Can they devise quantitative tests to put various materials in an order of visibility when seen in dim light?

Make some observations of people using light-controlled pedestrian crossings. Can the children time the sequence of events?

What colours are used on the crossing? How long does each last?

Is the timing affected when pedestrians press the crossing button?

What proportion of pedestrians obey the light signals?

What time-lag is there between the lights stopping pedestrians and the appearance of lights allowing cars to pass?

How far would a car doing 20 . . . 30 . . . 40 mile/h [32, 48, 64 km/h] travel in this time?

Here, as with other traffic investigations, is a useful chance to discuss road safety and responsible behaviour for pedestrians in busy streets.

It's also an opportunity to talk about the safety colours associated with other methods of transport.

Why not discuss safety on the railway track?

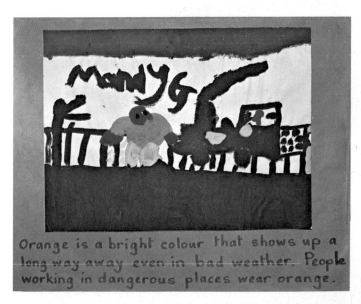

Orange is a bright colour that shows up a long way away even in bad weather. People working in dangerous places wear orange.

41

Observing buildings

Looking at building materials
Search out the coloured stones and bricks used in local buildings. Is there any connection between the different colours and the ages of the buildings?

Why not make a collection of building materials? If stone is quarried locally, the quarry is worth a visit. Profitable observation can be made of many things. Look at the colour differences between old and recently cut surfaces. Discuss the use of colour in machinery and protective clothing. Encourage observation of the colour of things leaving the quarry. Is the dust the same colour as the rocks? Is any water running from the quarry coloured? If so could the children devise ways of removing the colour from the water?

Of course observation on the visit will not be confined to coloured things, some children will possibly develop a wider interest in rocks and might collect a range of specimens.

Among other things they might investigate aspects of rock colour.

Which rocks are made up of one colour only? . . . of two colours? . . . of three colours?

When rocks contain fossils are they made up of few colours or many colours?

Are rocks the same colour all the way through?

Some children may branch out into a study of minerals and gem stones, and may learn to recognise certain of these by their characteristic colour. But do remember, and help the children to realise, that rocks and minerals cannot be identified with any certainty by colour alone.

Others, in making rock collections, may come to study pebbles and work might again involve colour. Let them observe wet and dry pebbles and perhaps find problems to be investigated. Is there, for example, any connection between the colour of pebbles and their shape? If their answer is 'no'—as it is likely to be—this is not wasted effort. They will have had valuable experience of organising and analysing observations in attempting to solve the problem. Further, they can be helped to appreciate that *no . . .* is frequently as satisfactory an answer as *yes.*

General experience of the colour of rocks and minerals will prove valuable for later work, but at this stage chemical details are not very meaningful.

All buildings make excellent topics for investigation and you will find many suggestions for work in the Project's Unit *Structures and forces Stages 1 and 2.* Here let us look at some buildings with a special purpose which provide opportunity for working with coloured things.

Looking at churches
If there is a nearby church that can be visited have a good look at its outside appearance.

Are there colour clues that indicate repair or extensions to the building?

How many different kinds of coloured stone can the children observe outside, and inside, the building?

How many different kinds of coloured metals?

Children visiting a church with their eyes open to colour will most obviously comment on any stained glass present (though some may contribute less obvious points of interest, such as the colour of the altar cloth in colour-coding the church year).

What can they notice inside the church when sunlight streams through the stained glass? Are there any coloured beams? . . . patches? . . . shadows? If so, are they connected in any way?

Will they notice the same things if they stand outside on a dark night and look at windows lit from inside?

How old are the windows? There may be a chance to compare medieval and modern glass. Are they in any way different?

What are the commonest colours used?

How is coloured glass made? Perhaps someone can do some research here.

The children will enjoy making 'stained glass windows', using coloured tissue or cellophane set in stiff card.

Inevitably some colours in the window will fade more quickly than others and provide opportunity for further investigation (page 49).

If you have a collection of coloured glass, help the children to explore its properties. What happens when sunlight passes through coloured glass on to white paper? . . . on to different coloured paper?

What happens if they vary the colour of the glass?

observations in some organised way. Here's one possible pattern:

This is the paper we used	This is the colour of the glass we used	This is the colour the paper looked
Specimen of paper		

Work of this nature will dovetail well with suggestions in the section about changing colours (Chapter 2).

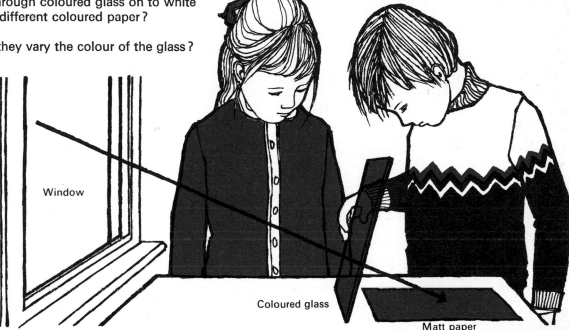

Window

Coloured glass

Matt paper

What happens if they use more than one piece of glass together? Try using pieces of the same colour.

Try also pieces of different colours.

It is important at this stage that children *explore* the possibilities. Few will work systematically and it would be wrong to impose a restricted pattern of working too early. Now they are discovering *what* happens: later in an attempt to discover *why* it happens they will work differently.

However, they might finally record their random

Perhaps windows could be made with 'proper' glass. The children will obviously need some coloured glass and the yellow pages of the telephone directory may reveal a local source of offcuts.

They can then set the glass in plaster of Paris.

Making a coloured glass window
Roll out some clay or Plasticine and make a glass and clay sandwich.

Place the sandwich in a shallow box and pour in plaster of Paris.

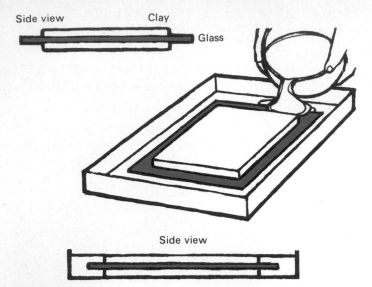

Side view Clay

Glass

Side view

(The sandwich can also be cast on a lightly greased sheet of glass with Plasticine retaining walls.)

After twenty-four hours remove the box (or glass) and roll off the clay.

Glass

With practice children might cast a 'window' containing many pieces of glass. If their work is to be kept out of doors ready mixed sand/cement should be used instead of plaster of Paris.

When considering churches as a source of coloured things don't forget the colours of polished stones in tombs and church yards. Children are not likely to find the malachite photographed here but they could find equally fascinating patterns to stimulate artwork and further exploration.

Concentrate on a few colourful things sold in shops.
Is there any connection between their colour and their
taste? Investigation of sweets are profitable and popular.

Is there any connection between the colour and taste of
sweets? Fruit gums and Smarties are worth exploring.

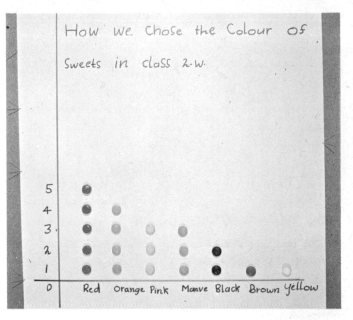

How we chose the Colour of
Sweets in class 2.W.

Red Orange Pink Mauve Black Brown Yellow

Looking at shops
Most shops have some potential for investigating
coloured things and supermarkets most of all.

Discuss the use of colour in packaging goods. Are some
colours, or colour combinations used more often than
others? Which do the children find most appealing?
Such an inquiry will link nicely with observations of
advertisements and window displays in the street.
Discussions of eye-catching colours can lead to work on
colour visibility (page 35). It might also promote
investigations to test the truth of certain advertising
claims.

What things are sold in coloured transparent containers?
Are there reasons for this?

How many labels show that the contents contain a
'colour additive' or artificial colouring? Here is a link
with food and drink colours (Chapter 5).

Which sweets leave a coloured tongue when eaten?

What other things do this?

If different-coloured sweets are sucked in succession do
they colour-mix on the tongue?

Do certain colours of the same kind of sweets take
longer to suck away than others?

How do the results compare with what happens when
similar sweets are dissolved in water? Fruit gums and
pastilles yield interesting results.

Can anyone find a way to remove the colour from one
sweet and use it to colour another colourless one?

These are but a few of the possibilities that shops offer
for working with coloured things. Why not note some
more when out shopping?

5 Home colours

There is much scope for interesting work. Starting points abound and discussions with the children about the use and occurrence of colour in their homes can promote much activity. There are observations to be made—things to be seen and talked about that have previously gone unnoticed. There are collections to be made—fabrics, papers, liquids, powders to be brought to school and examined. And there are things to be investigated because close contact with coloured things will likely give rise to questions and problems worth pursuing. Some of these will relate directly to colour: others will spin off in different directions.

Investigating paints

Finding popular colours
What is the most popular colour in the children's homes? Is it the most commonly occurring colour?

Here's opportunity for the children to collect and organise data. Young children might operate on a very limited scale, perhaps just investigating the use of paint in say their own bedrooms. Older children can have greater challenge:

How will they assess 'commonest'?

Is it whether it occurs or not?

Is it the amount they see?

What information should they collect? Will they look at the house as a whole or should they carry out a survey of particular rooms?

How will they record their findings? Encourage a variety of graphical work.

Considering paint names
Provide some paint manufacturers' colour charts. Which names interest the children? Are they good descriptive names?

'These are the names I chose

Midnight blue
Forest green
Ganges yellow

They make me think of being an explorer.'
Steven, ten years old.

What interesting names would they invent for various colours?

Would anyone not seeing their colour really know what it looked like?

Some enjoy choosing a name and then getting a partner to paint the colour he thinks the name represents.

Work of this nature can lead to an appreciation of the need for standardised ways of describing and reproducing colour, and discussion of British Standard numbers for paints is relevant here. There may be a local paint shop with a colour mixer where someone can find out more about the subject.

Exploring household paints
Provide a range of different paints. The children will be able to add to the collection. Try to include samples of gloss paint, emulsion paint and have available water and white spirit as paint thinners. Make sure there is a variety of different surfaces available for painting. Include wood, plastics, metal and ceramic things.

The children will need lots of paint containers that can be thrown away after use and a supply of old brushes and if possible paint rollers. They will also need protective clothing. Let them explore freely at first with the general aim of finding out more about the materials. But look for opportunities to extend their activities, in particular encourage discussion of fair tests to discover more.

Which paint dries fastest? Children will need to devise a method of applying each paint in a fair manner and a reliable means of timing proceedings, including an assessment of whether or not the paint is dry. In one school dryness was assessed every half-hour by a finger dipped in black powder paint. Originally planned as a nicety to prevent dirty fingers the method proved valuable as for quantitative recording. If the paint

wasn't dry the black stuck on and a final comparison of drying power was made in terms of the number of black marks on each sample. The photograph on page 48 shows the children at work.

Which paint is most resistant to wear? Which is most waterproof? Here again is scope for devising fair tests.

What is the effect of 'thinning' a paint?

Does it make it go further and, if so, how much further?

Does it make it dry quicker, if so, how much quicker?

Does it make it last longer, if so, how much longer?

Does it alter its colour?

What is the best method for cleaning paint brushes?

Can anyone suggest a fair test?

Note. Some commercial preparations contain caustic chemicals and *caution* in their use is necessary.

Side by side with practical activities there are opportunities for reading for information.

What is paint made of?

How is it made?

What is used to give it different colours?

Has it always been made as it is today?

Try making some paint. There may be a local shop selling pigments that the children can use. (*Note.* Do not buy poisonous lead-based pigments.) Let them experiment mixing pigments with linseed oil and small amounts of white spirit and terebine drier. Inevitably this is a messy business and suitable precautions are essential. But in the course of the children's exploration profitable lines of investigation may arise.

How for example can they get an even paint mixture?

How can they control the drying rate of their paint?

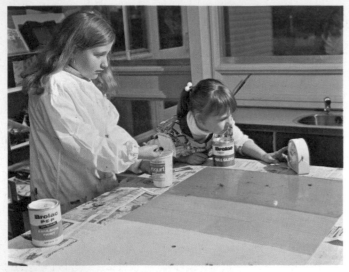
Which paint dries fastest?

Exploring artists' materials

Have a discussion about artists' use of paints. You might consider pictures decorating school and home and perhaps talk about different kinds of colour production. Someone might glean information from a museum or an art gallery. How many different kinds of material are used there to produce colour? Do any painters seem to have particular colour preferences?

What was used to produce coloured pictures before paint was manufactured? Children enjoy the challenge of producing pictures without using any man-made materials except paper to paint on. Let them try such things as clay, home-made charcoal, flower petals.

Exploration of the properties of different artists' materials is also worth-while experience. It's messy but fun and provides good opportunity for observation and experiment.

Provide a variety of materials that give say a blue colour. Include poster paint, water colour, gouache, oil paint, wax crayon, chalk, ink, felt pens. Can the children add others? Let them explore what happens when each is applied to a wet surface. Which mix with water? Which do not?

What happens when those that mix with water dry out on different papers? Try a range of papers including newsprint and blotting paper and encourage the children to explore with their paper held horizontally *and* vertically. They will discover some intriguing patterns. Can they use their observations to predict what will happen if they mix different media?

Investigating wallpapers

Making a collection

Make a collection of all kinds of wall 'paper'. Include lining paper, 'ordinary' wallpaper, washable varieties and hessian. Out-of-date pattern books from a decorator's shop are a useful source of material.

Let the children add to the collection and find ways of classifying the samples. They might investigate preferences within the class. Given a choice of say ten papers which would they choose? Encourage discussion of reasons for their choice and they will need to talk about their response to pattern, texture and colour.

What was it about their paper that appealed to them?

Could they design a fair test to investigate colour preferences *only*?

What evidence can they collect, from a wallpaper sample-book, about the colour preferences of the general public?

Work of this kind is valuable experience of collecting, organising and interpreting information.

Exploring properties

Have a discussion of things that make a good practicable wallpaper. Talk about easy application, resistance to wear and colourfastness. These are all properties that could promote investigational work and involve children in devising fair tests.

Which of their collection of papers is strongest when wet?

How can they measure the paper's strength?

Which is most resistant to grease marks? Can they work out a fair investigation?

Which is most resistant to mechanical wear and tear?

Which fades most? A simple experiment was devised by one group of children. They pasted wallpaper on hardboard and covered one part of each sample with black paper Sellotaped in position. The boards were left in a place receiving strong sunlight and examined periodically to compare the paper fully exposed to light with that under the black paper.

How might the experiment be made more quantitative?

Do cheap papers fade more readily than others?

Do some colours fade more readily than others?

The value of this work lies in children devising and designing their own tests. If they are merely provided with materials and instructions for work, they are missing out on an important area of possible experience. This point becomes clear if we interpret the situation in terms of its inherent objectives.

Hanging paper

Let the children try some small-scale paper hanging, perhaps decorating a dolls' house. They will then be directly involved in a practical situation likely to generate problems worth pursuing.

They might consider the properties of various wallpaper adhesives.

Provide a range for exploration. (*Note.* Some heavy-duty adhesives contain poisonous fungicides. If included they should be treated with care and the children must wash their hands after using them.)

Which adhesive goes furthest?

Which is strongest?

Which dries quickest?

Can a group devise some fair tests?

If the adhesives are diluted are their properties altered?

Sticking small bits of wallpaper on surfaces is an interesting task for young children, but why not consider working on a larger scale with older children. There may be some old wall available that won't hurt or it might be possible to provide a semi-realistic situation by tacking cardboard to a cupboard door. This will give a good working surface that can be easily removed if disaster strikes.

Initially the children will have great difficulty in deciding how best to paste and hang the paper. Let them explore possibilities, allowing for likely mess! If they remain stumped they will find the following method helpful.

Paste the bottom end of the wallpaper

Having folded over the pasted portion so that it attaches to the rest of the paper, finish the pasting

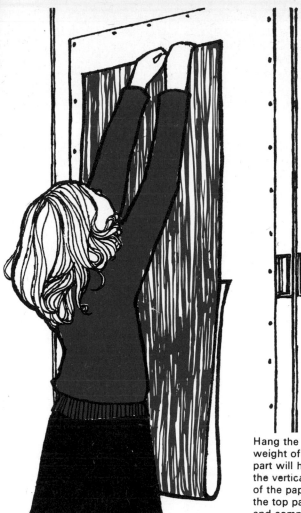

Hang the paper. The
weight of the folded
part will help with
the vertical positioning
of the paper. Smooth
the top part, unfold
and complete the job

If they use paper with a challenging 'pattern repeat',
then recognition of regularity of pattern will be
prominent in their work.

Experience of this kind will give them the taste of the
'real thing' and some may like to develop their
capabilities by estimating and costing the materials
required to say, paper the classroom. It's not likely that
they can actually put their findings into practice, but the
really proficient might possibly be involved in a local
community project helping old people with home
decoration.

Discussing colour 'mood'

Any work with wallpapers can lead to discussions of
the 'mood' of various colours. Encourage a collection of
pictures of various decorative schemes. Can the
children link each with an appropriate descriptive word.
Is the room exciting, restful, cool, warm . . . ? Try
extending their discussions in a practical way. Let them
construct some 'rooms' and decorate them so that each
has a particular mood.

Don't forget the 'feeling' of space associated with
certain colour schemes. Is it true that light colours make
a room look larger than dark colours? This is a good
problem to tackle.

Here's how two ten-year-olds tackled the problem.
They made mock-up rooms from expanded polystyrene
tiles held together with Sellotape. One room was
painted light blue, the other dark blue. They put
identical toy furniture in each room and the rest of the
class were asked if the rooms were the same size or not.

It soon became obvious that although their rooms were
well constructed, the experiment was badly designed
since everyone could see that the tiles were a standard
size. The problem was then one of letting others see the
inside of the rooms without being able to judge size by
outside dimensions. The two boys found an ingenious
way to overcome the difficulty, by obscuring the outside
of the rooms in a larger box.

Are the rooms the same
size?

Other children will find other solutions and it is this
element of not knowing the final result that makes
open-ended investigations so satisfying to teachers.

Investigating fabrics

Sorting and testing
Establish an exciting collection of coloured fabrics. It will make a ready source of material for collage work and can stimulate work in science.

How many ways can the children find for sorting the collection? Most obviously they could use colour differences and here's the start of work on colour preference, colour visibility, colour 'mood', colour descriptions. They might use other sorting criteria—let them explore freely. Perhaps someone will use 'kind of material' as a basis for their sorting; and here is the lead in to work involving natural and artificial materials.

Where do they come from?

How are they made?

There's a lot of reading to be done. There's practical activity too. Teachers may find the table on the opposite page helpful for distinguishing fabrics. It is not recommended for young children's use, but some upper juniors have used it successfully under supervision.

Children enjoy naming things, but encourage sorting that involves practical exploration. Try some of these:

Colourfast and not colourfast.

Waterproof and not waterproof.

Hardwearing and not hardwearing.

Shrinkproof and not shrinkproof.

Inevitably there will be disputes over what goes where for it's not possible to neatly categorise fabrics in this way. This is the point at which controlled testing and ordering becomes appropriate.

How much more, say, colourfast is one material than another? Can anyone devise a reliable method for getting a quantitative result?

Colouring fabrics
If work with coloured things is underway, try giving children a challenge they enjoy.

How many different-coloured marks can they collect on white material using things found outside the classroom? Cotton fabric is most suitable and you may get some old pillow-cases brought in.

How many of the marks remain if the fabric is washed in cold water? How many are left after warm-water washing? Can they use their findings to prepare some cold water and warm water dyes? Encourage them to supplement their dyes with other readily obtained materials such as coffee, nutmeg, fruit juice.

Many of the things children try as a colour source will not give up their colour in cold or warm water, and teachers might set up a dye-bath that can be raised to boiling point and kept simmering—a large enamel saucepan will do nicely. Comprehensive instructions for natural dyeing will be found in *The Use of Vegetable Dyes* by V. Thurstan, Dryad Press. Minimal instructions are given below.

Tie the finely chopped dyestuff in a muslin bag.

Put the dye bag in cold, preferably soft, water.

Bring to the boil and then simmer.

Key for identifying some common fabrics

1. Take a few threads of the fabric. Hold them in tweezers over an ash tray and bring them *towards* a burning match. Look at the fabric as it gets *near* the flame.

Does it melt?	Yes	go to 2
	No	go to 5

2. Now burn a little of the material (care: do not let it touch your skin).

Is it difficult to burn?	Yes	Nylon
	No	go to 3

3. Look at the flame.

Is it sooty?	Yes	go to 4
	No	acetate Tricel

4. Look at the remains after burning.
 Are they:

Smooth surfaced?	Terylene, polyester
Irregular and lumpy?	acrylic, Orlon, etc.

5. Burn a little of the material.
 What does it smell like?

Bad fish (leaving blackened ash skeleton of fibre)	resin-finished rayon or cotton
Burnt hair (ash soft and bulbous)	go to 6
Burnt paper (little ash)	go to 7

6. Take a few more threads and examine them closely.
 How are they arranged?

As continuous filaments, fine and flexible	silk
As smaller threads (staple) spun together	wool

7. Examine a few more threads closely.
 How are they arranged?

As continuous filaments	rayon
As smaller threads (staple) spun together	go to 8

8.
Does the staple vary in length?	Yes	go to 9
	No	spun rayon

9.
Is the staple stiff and coarse?	Yes	linen
	No	cotton

This key is adapted from the pamphlet A Handy Way to Identify Textiles, *produced by the British Man-made Fibres Federation, Bridgewater House, 58 Whitworth Street, Manchester M1 6LS.*

Add the fabric to be dyed (wool will take up natural dye better than other fabrics).

Keep simmering, stirring occasionally until the desired colour intensity is achieved. Remember the fabric will look darker when wet and will continue to take up colour after it is removed from dye-bath.

Allow the fabric to cool, then squeeze and rinse until no further colour comes away.

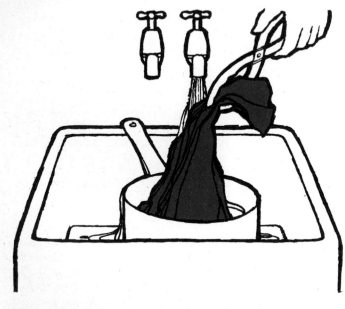

When children use their own dyes it is important that their first attempts should be exploratory ones. The pleasure of producing different colours is sufficient reward at this stage and over-direction of their activities can kill enthusiasm. But dyeing can be a messy business and teachers may find it advisable to organise protective clothing and possibly rubber gloves or tongs to prevent multicoloured hands.

When the excitement of causing fabric to change colour diminishes try some tie dyeing. It's a popular activity and one which can lead to other kinds of exploration. You will find full instructions for methods of tie-dyeing in a useful free pamphlet produced by Dylon dyes. It is called *Tie-dye*. Here we will record the minimal working details:

1. Use clean ironed cloth.

2. Tie up the cloth (see below for various methods).

3. Dye.

4. Rinse.

5. Untie.

There are various ways of tying the cloth to produce patterns. Try *tying in objects* such as pebbles, corks, buttons, seeds.

First put objects on the cloth.

Then bind the object using cotton, thread or string.

There are interesting variants of this method:

1. Try varying the number of objects.

2. Try varying the number of bindings.

Try also *making knots* to produce patterns.

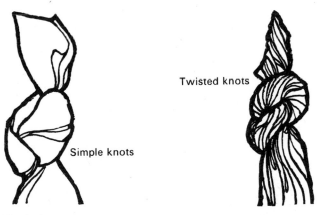

Twisted knots

Simple knots

All kinds of pattern and colour variations are possible by varying the 'tie' and the colour of successive dyes. The results delight children and may stimulate interest in the process itself.

How does it happen? What stops the dye reaching parts of the cloth? Can they make a collection of things that resist liquids? Could any be used to make patterns when fabric is dyed? Try using candlewax. Try other things. This is an example of how an exploration of properties can arise from work that has seemingly little to do with science.

Let's look now at ways of extending an interest in dyeing.

Using mordants
With a lot of simple experience of dyeing behind them children could be introduced to the idea of using a mordant to prepare materials for dyeing. Alum is most commonly used and obtainable from chemists. You will find in the Dryad publication *The Use of Vegetable Dyes* details of other mordants and their use.

Let the children investigate dyeing similar fabrics with and without a mordant.

Do they get any colour difference?

Is one more colour-fast than the other?

Is one more resistant to fading?

How will they make a 'fair' test to find out?

Will they get similar results using different fabrics? Cotton, nylon, terylene and wool are good fabrics for comparison.

In this manner they will begin to think more closely about the process of dyeing itself, rather than just concentrating on the end product.

Investigating the dyeing process
Provide some commercial household dyes. Dylon cold water dyes are useful. The Dylon instant fabric dyes are also good but since they are used with hot water they may present difficulties in the average classroom. But this disadvantage, if overcome, is in fact an advantage since it offers one more factor for investigation. What things affect the way fabric takes up dye?

Let the children dye fabrics following the manufacturer's

instructions exactly and then investigate what happens if they fail to do this.

What happens if they alter the temperature of the water?

What happens if they alter the amount of dye they use?

What happens if they don't stir?

Are their tests fair ones?

They might also investigate the manufacturer's over-dyeing chart. Do their results agree with the chart?

Activities of this nature will give the children experience of organising and controlling experiments. They will not understand the complex chemistry involved: sufficient that they begin to appreciate that dyeing is a complicated process whose results depend on various factors. Later they may come to isolate these variables.

Removing colours

Link the work with activities of the kind described on page 52. If water will not remove coloured marks, what will? Have a discussion of common stains that resist normal washing.

Perhaps the children could gather mothers' opinions about the best way to remove a particular stain from a particular fabric. Let them then put opinions to the test to discover the most effective methods. It must be a fair test.

Many magazines give 'household hints' on stain removal. Are their recommendations effective ones? On the right is one such chart. Do the suggestions really work? Are they equally effective on fresh and old stains?

It is likely that the children will encounter greasy stains, such as lipstick and shoe polish, that can only be removed by proprietary cleaners containing a grease solvent. Be careful here for *such solvents can be dangerous:* they are highly inflammable and also harmful if inhaled in an ill-ventilated room. Should children handle them they must be aware of the dangers. In any case it is worth while informing the class of the hazardous properties of these common household stain removers.

Bridge Farm Junior School,
East Dundry Road,
Whitchurch,
Bristol.

Dear Parents,

We are conducting a class survey about "What methods of removal for a variety of stains are most common in this area" e.g. grass stains, tea, coffee, tar, grease, paint, fruit juice, etc. Would you be kind enough to indicate below any stains and methods of removal which you have found successful. Thank you for your anticipated co-operation.

Yours sincerely,

M. ARDRON

STAINS. METHOD of REMOVAL USED.

grass-stains. Soak stain in a shallow bath of methylated spirit until stain has gone.

tea. If dry. Pour hot water slowly over the spot already covered with borax, then soak in hot water. 2 teaspoons borax to ½ pint

coffee. (white) If stain has dried rub in a little glycerine. If wet wash immediately.

tar. Put a little butter on the spot.

grease. Spirit

paint. Rub with turpentine

fruit juice. Soak stain in a solution of borax & warm water. (one teasp. to ½ pint)

Stain	Treatment
Blood Egg Gravy	Soak stain in cold water and then use an enzyme powder as directed on the packet. *Note. These powders can cause a skin reaction in some children. Thorough hand rinsing after their use is recommended for everyone.*
Grass Ballpoint ink Indelible pencil	Rub stain with methylated spirit turning the cloth frequently. Launder. *Note. As meths is inflammable never use it near a naked flame.*
Cocoa, tea, coffee Fruit juice Red ink	Dampen stain, sprinkle with borax (obtained from a chemist) and pour on warm water. Launder.
Dye stains on white fabrics	Use a proprietary dye remover.

Investigating food and drink

Collecting and exploring
Make a collection of the colourful food materials that can be found in a kitchen. The children will be surprised by the variety of colour available for it is so often hidden to them by hygienic wrappings.

Start the collection with the general aim of seeing how many colours the children can discover, but look for opportunities to extend their activities to explore properties of the things they bring in. You will find helpful suggestions in the Project's Unit, *Change Stages 1 and 2*. Here let's concentrate on activities relating to the colour of things.

Have a discussion about food colours. How much does colour influence whether or not we like a particular food? Would anyone enjoy green custard? Here's a place to introduce *edible* food colourings. Try changing the colour of some common foods. Does their taste change? The products can be used to devise fair tests for investigating the role of colour, texture and taste in food preferences.

Finding colour changes
Talk about common foods that change colour when they are cooked. Let the children discover which of their materials change colour when heated. They can do this

safely by holding a small amount in a metal spoon over a candle flame. They will notice things other than colour change and their findings are valuable for setting activity. Which of their materials change colour when water is added? Are there different effects with cold and warm water?

Make a collection of coloured liquids obtained from food and drink materials. If the liquid disappears will the colour go too?

Put small amounts of the liquids in shallow containers to evaporate over a radiator or in the sun. It is best to use light-coloured containers.

Let drops of the liquid evaporate on different surfaces. Include newspaper, blotting paper, glass and a mirror.

Activities of this nature give useful informal experience of changes that can be built upon later. At this stage children will benefit from wide general experience and their fascination for coloured liquids will likely lead them away from an interest in food and drink colours to explorations of coloured solutions.

Working with coloured liquids

Provide a good variety of coloured solutions. They are fun to make from Boots' food colouring liquids and there may be others available if the children have collected solutions for dyeing (page 55). Ink is good too.

Let them explore freely, suggesting profitable lines of inquiry if ideas do not come readily.

Initially they are likely to work on a large scale, exploring what happens when they mix different liquids, but look for opportunity to develop their general observations.

Try working with *drops* of coloured liquid.

Children can devise their own way of making drops but it's often a more difficult task than is at first thought apparent so have some plastic straws and eye-droppers available for use.

Encourage observations of the patterns made by adding coloured drops to colourless liquids.

Try water.

Try other liquids.

Will they get the same patterns if they add the drops to *warm* water? What happens if they add *hot* drops to cold water? One infant at work is shown on page 60.

How many ways can they find to spread the colour of a drop throughout the water?

Can they find ways of making the colours from different-coloured drops meet? On the right is one suggestion: there are others.

What can they notice if they add coloured drops to the surface of water in tall narrow containers?

Will the colour reach the bottom?

Can they invent a way of adding a drop of coloured solution to the *bottom* of the water? . . . to the *middle*?

How do coloured drops behave in other liquids?

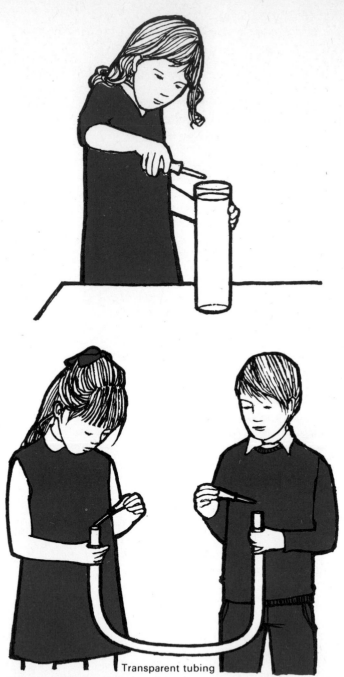

Transparent tubing

Work of this nature provides good observational experience and opportunity for developing manipulative skills.

Diluting things

How much water must be added to a single coloured drop to make its colour disappear? Let them guess first and then find out practically. This is useful experience of dilution which with similar experience will help their later understanding of solution concentrations. Encourage activities that involve changing the colour intensity of particular solutions and aim for rough quantitative assessment.

It's a good idea to work initially with coloured materials that can be handled as reasonably standard units, so jelly cubes, tea-bags and coffee-bags are suitable things to use. Let the children try making colour-graduated solutions, using one unit, two units, three units . . . each in the same volume of water. How do they compare? There's a danger here that the work may be meaningless to the children. Certainly if it is introduced as a directed activity there will be little point to it, so it's important that activities of this kind are conducted in a spirit of inquiry with a 'what happens when . . .' approach.

When they have had some experience of diluting things in this manner some may be ready for more challenging work. Can they for example make a graduated series of coloured icing sugar samples to provide a colour standard for decorating cakes? They will need a lot of discussion and trial and error working before they have mastered the task.

If someone chooses a colour from their standard range, could they reproduce the coloured icing in sufficient quantity to ice a birthday cake?

Work such as this can be fun and it will also help later appreciation of the use of comparative colour standards in science.

Looking at hot things

Many things in the home show interesting colours when hot. Children are familiar with them as sources of heat and light but seldom have observed them closely. Certainly they do not immediately associate them with colour changes. Yet once interest is aroused they give good opportunity for observational work.

Here's a nine-year-old writing about an investigation which followed a general discussion of fires.

'We got the electric fire from the staff room. When we switched it on it started out black then went browny then red. It took fifteen seconds to turn red and one minute to become bright red. John timed it on his watch. It took twelve seconds to go black after we switched it off.'

'The fire has lots of coils of wire which light up and make heat. The colour gets brighter the longer the fire is on. Some parts of the fire were redder than others because these places were probably a bit hotter.'

This is excellent observation and its fine detail indicates how deeply Ann was engrossed in her investigation. She was consciously learning things about one particular fire; unconsciously building up experience that will help her later general appreciation of energy changes.

Other things encourage equally valuable observation.

Finding colours in burning things

In this and the following section there is clearly a slight element of danger. Matches, candles and fires can be hazardous things if carelessly employed. But children who have discussed with their teacher the need for safety precautions often make ingenious and highly practical suggestions for safe methods of working. Indeed it is valuable for them to do dangerous things occasionally and carry them safely through by taking adequate precautions.

Let the children look carefully at a match flame.

What colours can they see?

Do the colours change as the match burns away?

Do red- and brown-topped matches have different-coloured flames?

Is a candle flame the same colour as a match flame?

Do candles of different colours have different-coloured flames? Has each flame an identical colour pattern?

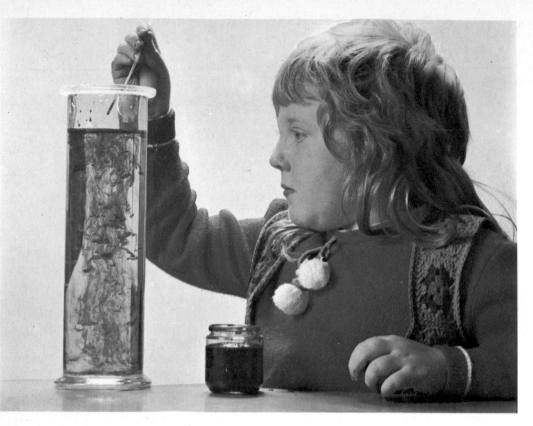

Encourage a search for patterns in the colours of hot things.

The child in the photograph found them by adding hot drops to cold water as described on page 58 but her activities could equally well have developed from looking at the pattern in a candle flame. It's a good example of the flexibility of approach implicit in the Project's method of working.

But let's return to candles.

When we dropped the purple in it went like a drill going round and round and when we put the orange drop it went down faster than the purple drop.

It's worth encouraging discussion of their colour. How did it get there? Could anyone make a coloured candle?

There's scope here for ingenious devising of methods and manipulation of materials. But be sure to have a full discussion of safety precautions: hot wax can be dangerous.

How many children have open fires at home? Perhaps they could observe their fire colours and report back.

Are the colours the same for coal fires and for fires made from smokeless fuel? What about the colours produced by a wood fire?

Consider making a bonfire. It's great fun and a good source of observations.

Can the children find ways to change the colour of its flames?

Can they change the colour of its smoke?

Note. Discuss with children the dangers of indiscriminate throwing of things on fires. Aerosol canisters are particularly lethal.

Don't forget to look at the cold remains of the bonfire to discover what has changed colour. Try using the materials for art work. Finally, while in a bonfire mood, consider collecting observations of firework colours.

Colours from electric things

Get the children to bring some torches to school.

Whose gives the brightest light?

Whose gives the dimmest light?

Can they arrange their torches in order of brightness?

Are there colour differences?

Will they get the same order if they remove the reflector from each torch?

Do bigger torches give brighter lights?

Here's opportunity to talk about bulbs and batteries and how they are connected. Lots of investigations are possible. For instance they might like to find out what happens to the light, and how long it takes to happen, when a battery 'runs down', or they might find out what's inside a battery. You will find further suggestions in the Project's Unit, *Metals Stages 1 and 2.*

Equally the children might go off at a tangent. How many ways can they discover to alter the colour of the light given out by a particular torch? This is likely to lead to working with filters (pages 15-16). It could also involve explorations of how various lampshades affect the colour of light in a room.

Have the children ever looked closely at a light bulb when it is lit up? Give them an opportunity. But remember that staring at the inside of a bright light can damage eyes. The children should appreciate this, but may safely observe a lower-power bulb as shown below.

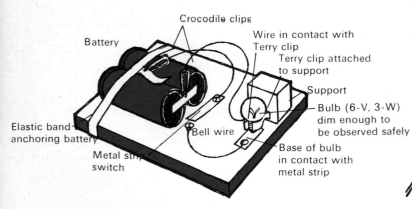

Crocodile clips

Battery

Wire in contact with Terry clip

Terry clip attached to support

Support

Bulb (6-V, 3-W) dim enough to be observed safely

Elastic band anchoring battery

Bell wire

Metal strip switch

Base of bulb in contact with metal strip

Which part of the bulb gives out light?

What colour is it?

Collect some pearly bulbs of different 'power' from the same manufacturer. 40-W, 60-W, 100-W and 150-W bulbs are good. What differences can the children discover in the unlit bulbs? Let them list the differences including information written on the bulbs. What differences can they discover when the bulbs are switched on? An easy way to compare lighted bulbs using a 'brightness tester' is shown below. The 'brightness tester' is aimed at each bulb in turn and its brightness is judged by the number of holes that can be counted. The more holes seen, the brighter the light.

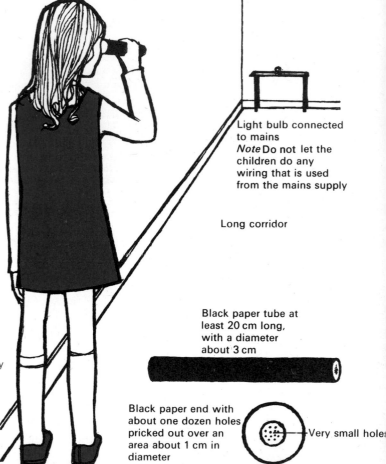

Light bulb connected to mains
Note Do not let the children do any wiring that is used from the mains supply

Long corridor

Black paper tube at least 20 cm long, with a diameter about 3 cm

Black paper end with about one dozen holes pricked out over an area about 1 cm in diameter

Very small holes

Is there any connection between the colour of the bulb and how hot it gets? Children will need to think out ways of investigating this without burning their fingers,

and be sure to first discuss their ideas with their teacher.

Can they find out about electric lights that don't get hot?

Perhaps someone can bring pictures of industrial furnaces that make things 'white-hot'. Maybe the school has an electric kiln and someone can use the peephole to record colour changes inside as the temperature increases.

Finding colours in the sky

Finally, although not found inside the home, it is appropriate to mention the sun and stars as other hot things that give coloured light. *Note.* Children should *never* look directly at the sun as this can cause irreparable damage to their eyes.

Are stars all the same colour? Encourage individual observations and a reporting-back session. They will find that stars vary in colour. This comes as a surprise to many and is yet another example of what can be seen once they start *looking*. Some will be more observant than others but all should be able to spot red-coloured Betelgeuse. This star occurs in the constellation of Orion the hunter and is seen at the shoulder of his club-holding arm.

Some children might follow up their observations by using books to find out more about the colours of stars. They will discover that stars are classified on a colour basis.

Perhaps also someone could do some research on the colour of planets. They may find limited reference sources but the subject lends itself well to imaginative treatment.

Betelgeuse

Orion the Hunter

And so we complete our look at coloured things. We started in the classroom and ended out in space. In doing so we've dipped into many topic areas and considered a wide range of children's activities. The Project hopes that teachers will select and develop ideas they consider appropriate for their children, working with them in a child-centred way and working also 'with objectives in mind'.

Objectives for children learning science

Guide lines to keep in mind

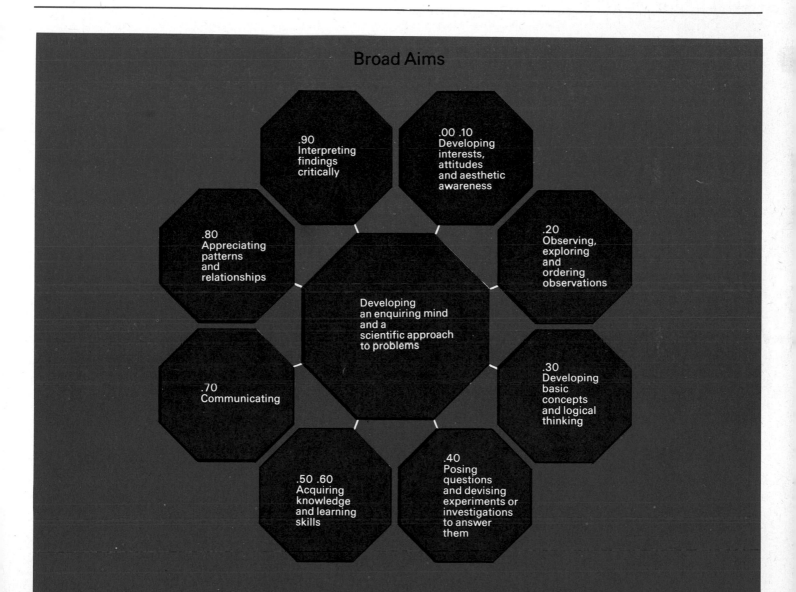

What we mean by Stage 1, Stage 2 and Stage 3

Attitudes, interests and aesthetic awareness

.00/.10

Stage 1
Transition from intuition to concrete operations. Infants generally.

The characteristics of thought among infant children differ in important respects from those of children over the age of about seven years. Infant thought has been described as 'intuitive' by Piaget; it is closely associated with physical action and is dominated by immediate observation. Generally, the infant is not able to think about or imagine the consequences of an action unless he has actually carried it out, nor is he yet likely to draw logical conclusions from his experiences. At this early stage the objectives are those concerned with active exploration of the immediate environment and the development of ability to discuss and communicate effectively: they relate to the kind of activities that are appropriate to these very young children, and which form an introduction to ways of exploring and of ordering observations.

1.01	Willingness to ask questions
1.02	Willingness to handle both living and non-living material.
1.03	Sensitivity to the need for giving proper care to living things.
1.04	Enjoyment in using all the senses for exploring and discriminating.
1.05	Willingness to collect material for observation or investigation.

- -

Concrete operations. Early stage.

In this Stage, children are developing the ability to manipulate things mentally. At first this ability is limited to objects and materials that can be manipulated concretely, and even then only in a restricted way. The objectives here are concerned with developing these mental operations through exploration of concrete objects and materials—that is to say, objects and materials which, as physical things, have meaning for the child. Since older children, and even adults, prefer an introduction to new ideas and problems through concrete example and physical exploration, these objectives are suitable for all children, whatever their age, who are being introduced to certain science activities for the first time.

1.06	Desire to find out things for oneself.
1.07	Willing participation in group work.
1.08	Willing compliance with safety regulations in handling tools and equipment.
1.09	Appreciation of the need to learn the meaning of new words and to use them correctly.

Stage 2
Concrete operations. Later stage.

In this Stage, a continuation of what Piaget calls the stage of concrete operations, the mental manipulations are becoming more varied and powerful. The developing ability to handle variables—for example, in dealing with multiple classification—means that problems can be solved in more ordered and quantitative ways than was previously possible. The objectives begin to be more specific to the exploration of the scientific aspects of the environment rather than to general experience, as previously. These objectives are developments of those of Stage 1 and depend on them for a foundation. They are those thought of as being appropriate for all children who have progressed from Stage 1 and not merely for nine- to eleven-year-olds.

2.01	Willingness to co-operate with others in science activities.
2.02	Willingness to observe objectively.
2.03	Appreciation of the reasons for safety regulations.
2.04	Enjoyment in examining ambiguity in the use of words.
2.05	Interest in choosing suitable means of expressing results and observations.
2.06	Willingness to assume responsibility for the proper care of living things.
2.07	Willingness to examine critically the results of their own and others' work.
2.08	Preference for putting ideas to test before accepting or rejecting them.
2.09	Appreciation that approximate methods of comparison may be more appropriate than careful measurements.

Stage 3
Transition to stage of abstract thinking.

This is the Stage in which, for some children, the ability to think about abstractions is developing. When this development is complete their thought is capable of dealing with the possible and hypothetical, and is not tied to the concrete and to the here and now. It may take place between eleven and thirteen for some able children, for some children it may happen later, and for others it may never occur. The objectives of this stage are ones which involve development of ability to use hypothetical reasoning and to separate and combine variables in a systematic way. They are appropriate to those who have achieved most of the Stage 2 objectives and who now show signs of ability to manipulate mentally ideas and propositions.

3.01	Acceptance of responsibility for their own and others' safety in experiments.
3.02	Preference for using words correctly.
3.03	Commitment to the idea of physical cause and effect.
3.04	Recognition of the need to standardise measurements.
3.05	Willingness to examine evidence critically.
3.06	Willingness to consider beforehand the usefulness of the results from a possible experiment.
3.07	Preference for choosing the most appropriate means of expressing results or observations.
3.08	Recognition of the need to acquire new skills.
3.09	Willingness to consider the role of science in everyday life.

Attitudes, interests and aesthetic awareness

.00/.10 **.20**

1.21 Appreciation of the variety of living things and materials in the environment.
1.22 Awareness of changes which take place as time passes.
1.23 Recognition of common shapes—square, circle, triangle.
1.24 Recognition of regularity in patterns.
1.25 Ability to group things consistently according to chosen or given criteria.

1.11 Awareness that there are various ways of testing out ideas and making observations.
1.12 Interest in comparing and classifying living or non-living things.
1.13 Enjoyment in comparing measurements with estimates.
1.14 Awareness that there are various ways of expressing results and observations.
1.15 Willingness to wait and to keep records in order to observe change in things.
1.16 Enjoyment in exploring the variety of living things in the environment.
1.17 Interest in discussing and comparing the aesthetic qualities of materials.

1.26 Awareness of the structure and form of living things.
1.27 Awareness of change of living things and non-living materials.
1.28 Recognition of the action of force
1.29 Ability to group living and non-living things by observable attributes.
1.29a Ability to distinguish regularity in events and motion.

2.11 Enjoyment in developing methods for solving problems or testing ideas.
2.12 Appreciation of the part that aesthetic qualities of materials play in determining their use.
2.13 Interest in the way discoveries were made in the past.

2.21 Awareness of internal structure in living and non-living things.
2.22 Ability to construct and use keys for identification.
2.23 Recognition of similar and congruent shapes.
2.24 Awareness of symmetry in shapes and structures.
2.25 Ability to classify living things and non-living materials in different ways.
2.26 Ability to visualise objects from different angles and the shape of cross-sections.

3.11 Appreciation of the main principles in the care of living things.
3.12 Willingness to extend methods used in science activities to other fields of experience.

3.21 Appreciation that classification criteria are arbitrary.
3.22 Ability to distinguish observations which are relevant to the solution of a problem from those which are not.
3.23 Ability to estimate the order of magnitude of physical quantities.

Developing basic concepts and logical thinking .30	Posing questions and devising experiments or investigations to answer them .40

Stage 1
Transition from intuition to concrete operations. Infants generally.

1.31 Awareness of the meaning of words which describe various types of quantity.
1.32 Appreciation that things which are different may have features in common.

1.41 Ability to find answers to simple problems by investigation.
1.42 Ability to make comparisons in terms of one property or variable.

Concrete operations. Early stage.

1.33 Ability to predict the effect of certain changes through observation of similar changes.
1.34 Formation of the notions of the horizontal and the vertical.
1.35 Development of concepts of conservation of length and substance.
1.36 Awareness of the meaning of speed and of its relation to distance covered.

1.43 Appreciation of the need for measurement.
1.44 Awareness that more than one variable may be involved in a particular change.

Stage 2
Concrete operations. Later stage.

2.31 Appreciation of measurement as division into regular parts and repeated comparison with a unit.
2.32 Appreciation that comparisons can be made indirectly by use of an intermediary.
2.33 Development of concepts of conservation of weight, area and volume.
2.34 Appreciation of weight as a downward force.
2.35 Understanding of the speed, time, distance relation.

2.41 Ability to frame questions likely to be answered through investigations.
2.42 Ability to investigate variables and to discover effective ones.
2.43 Appreciation of the need to control variables and use controls in investigations.
2.44 Ability to choose and use either arbitrary or standard units of measurement as appropriate.
2.45 Ability to select a suitable degree of approximation and work to it.
2.46 Ability to use representational models for investigating problems or relationships.

Stage 3
Transition to stage of abstract thinking.

3.31 Familiarity with relationships involving velocity, distance, time, acceleration.
3.32 Ability to separate, exclude or combine variables in approaching problems.
3.33 Ability to formulate hypotheses not dependent upon direct observation.
3.34 Ability to extend reasoning beyond the actual to the possible.
3.35 Ability to distinguish a logically sound proof from others less sound.

3.41 Attempting to identify the essential steps in approaching a problem scientifically.
3.42 Ability to design experiments with effective controls for testing hypotheses.
3.43 Ability to visualise a hypothetical situation as a useful simplification of actual observations.
3.44 Ability to construct scale models for investigation and to appreciate implications of changing the scale.

1.51 Ability to discriminate between different materials.
1.52 Awareness of the characteristics of living things.
1.53 Awareness of properties which materials can have.
1.54 Ability to use displayed reference material for identifying living and non-living things.

1.55 Familiarity with sources of sound.
1.56 Awareness of sources of heat, light and electricity.
1.57 Knowledge that change can be produced in common substances.
1.58 Appreciation that ability to move or cause movement requires energy.
1.59 Knowledge of differences in properties between and within common groups of materials.

1.61 Appreciation of man's use of other living things and their products.
1.62 Awareness that man's way of life has changed through the ages.
1.63 Skill in manipulating tools and materials.
1.64 Development of techniques for handling living things correctly.
1.65 Ability to use books for supplementing ideas or information.

2.51 Knowledge of conditions which promote changes in living things and non-living materials.
2.52 Familiarity with a wide range of forces and of ways in which they can be changed.
2.53 Knowledge of sources and simple properties of common forms of energy.
2.54 Knowledge of the origins of common materials.
2.55 Awareness of some discoveries and inventions by famous scientists.
2.56 Knowledge of ways to investigate and measure properties of living things and non-living materials.
2.57 Awareness of changes in the design of measuring instruments and tools during man's history.
2.58 Skill in devising and constructing simple apparatus.
2.59 Ability to select relevant information from books or other reference material.

3.51 Knowledge that chemical change results from interaction.
3.52 Knowledge that energy can be stored and converted in various ways.
3.53 Awareness of the universal nature of gravity.
3.54 Knowledge of the main constituents and variations in the composition of soil and of the earth.
3.55 Knowledge that properties of matter can be explained by reference to its particulate nature.
3.56 Knowledge of certain properties of heat, light, sound, electrical, mechanical and chemical energy.
3.57 Knowledge of a wide range of living organisms.
3.58 Development of the concept of an internal environment.
3.59 Knowledge of the nature and variations in basic life processes.

3.61 Appreciation of levels of organisation in living things.
3.62 Appreciation of the significance of the work and ideas of some famous scientists.
3.63 Ability to apply relevant knowledge without help of contextual cues.
3.64 Ability to use scientific equipment and instruments for extending the range of human senses.

Communicating	Appreciating patterns and relationships
.70	**.80**

Stage 1

Transition from intuition to concrete operations. Infants generally.

1.71	Ability to use new words appropriately.
1.72	Ability to record events in their sequences.
1.73	Ability to discuss and record impressions of living and non-living things in the environment.
1.74	Ability to use representational symbols for recording information on charts or block graphs.

1.81	Awareness of cause-effect relationships.

Concrete operations. Early stage.

1.75	Ability to tabulate information and use tables.
1.76	Familiarity with names of living things and non-living materials.
1.77	Ability to record impressions by making models, painting or drawing.

1.82	Development of a concept of environment.
1.83	Formation of a broad idea of variation in living things.
1.84	Awareness of seasonal changes in living things.
1.85	Awareness of differences in physical conditions between different parts of the Earth.

Stage 2

Concrete operations. Later stage.

2.71	Ability to use non-representational symbols in plans, charts, etc.
2.72	Ability to interpret observations in terms of trends and rates of change.
2.73	Ability to use histograms and other simple graphical forms for communicating data.
2.74	Ability to construct models as a means of recording observations.

2.81	Awareness of sequences of change in natural phenomena.
2.82	Awareness of structure-function relationship in parts of living things.
2.83	Appreciation of interdependence among living things.
2.84	Awareness of the impact of man's activities on other living things.
2.85	Awareness of the changes in the physical environment brought about by man's activity.
2.86	Appreciation of the relationships of parts and wholes.

Stage 3

Transition to stage of abstract thinking.

3.71	Ability to select the graphical form most appropriate to the information being recorded.
3.72	Ability to use three-dimensional models or graphs for recording results.
3.73	Ability to deduce information from graphs: from gradient, area, intercept.
3.74	Ability to use analogies to explain scientific ideas and theories.

3.81	Recognition that the ratio of volume to surface area is significant.
3.82	Appreciation of the scale of the universe.
3.83	Understanding of the nature and significance of changes in living and non-living things.
3.84	Recognition that energy has many forms and is conserved when it is changed from one form to another.
3.85	Recognition of man's impact on living things—conservation, change, control.
3.86	Appreciation of the social implications of man's changing use of materials, historical and contemporary.
3.87	Appreciation of the social implications of research in science.
3.88	Appreciation of the role of science in the changing pattern of provision for human needs.

.90

1.91 Awareness that the apparent size, shape and relationships of things depend on the position of the observer.

1.92 Appreciation that properties of materials influence their use.

2.91 Appreciation of adaptation to environment.
2.92 Appreciation of how the form and structure of materials relate to their function and properties.
2.93 Awareness that many factors need to be considered when choosing a material for a particular use.
2.94 Recognition of the role of chance in making measurements and experiments.

3.91 Ability to draw from observations conclusions that are unbiased by preconception.
3.92 Willingness to accept factual evidence despite preceptual contradictions.
3.93 Awareness that the degree of accuracy of measurements has to be taken into account when results are interpreted.
3.94 Awareness that unstated assumptions can affect conclusions drawn from argument or experimental results.
3.95 Appreciation of the need to integrate findings into a simplifying generalisation.
3.96 Willingness to check that conclusions are consistent with further evidence.

These Stages we have chosen conform to modern ideas about children's learning. They conveniently describe for us the mental development of children between the ages of five and thirteen years, but it must be remembered that ALTHOUGH CHILDREN GO THROUGH THESE STAGES IN THE SAME ORDER THEY DO NOT GO THROUGH THEM AT THE SAME RATES.
SOME children achieve the later Stages at an early age.
SOME loiter in the early Stages for quite a time.
SOME never have the mental ability to develop to the later Stages.
ALL appear to be ragged in their movement from one Stage to another.
Our Stages, then, are not tied to chronological age, so in any one class of children there will be, almost certainly, some children at differing Stages of mental development.

Index

Illustration acknowledgements:

The publishers gratefully acknowledge the help given by the
following in supplying photographs on the pages indicated:

BBC, 21 right
French Tourist Office, 45 left
Science Museum, 44
Zoological Society of London, 24 right

All other photographs by James Wright

Line drawings by The Garden Studio: Anna Barnard

Labelling and flow charts by GWA Design Consultants

Cover design by Peter Gauld